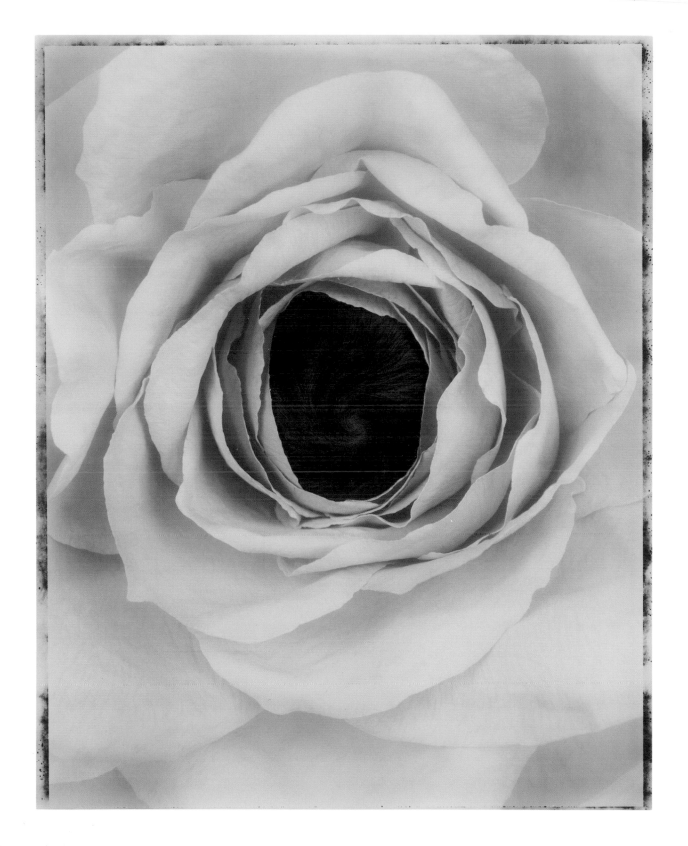

A *baby* is born with a ***need*** to be *loved*—

and never outgrows it.

Frank A. Clark (1911–)

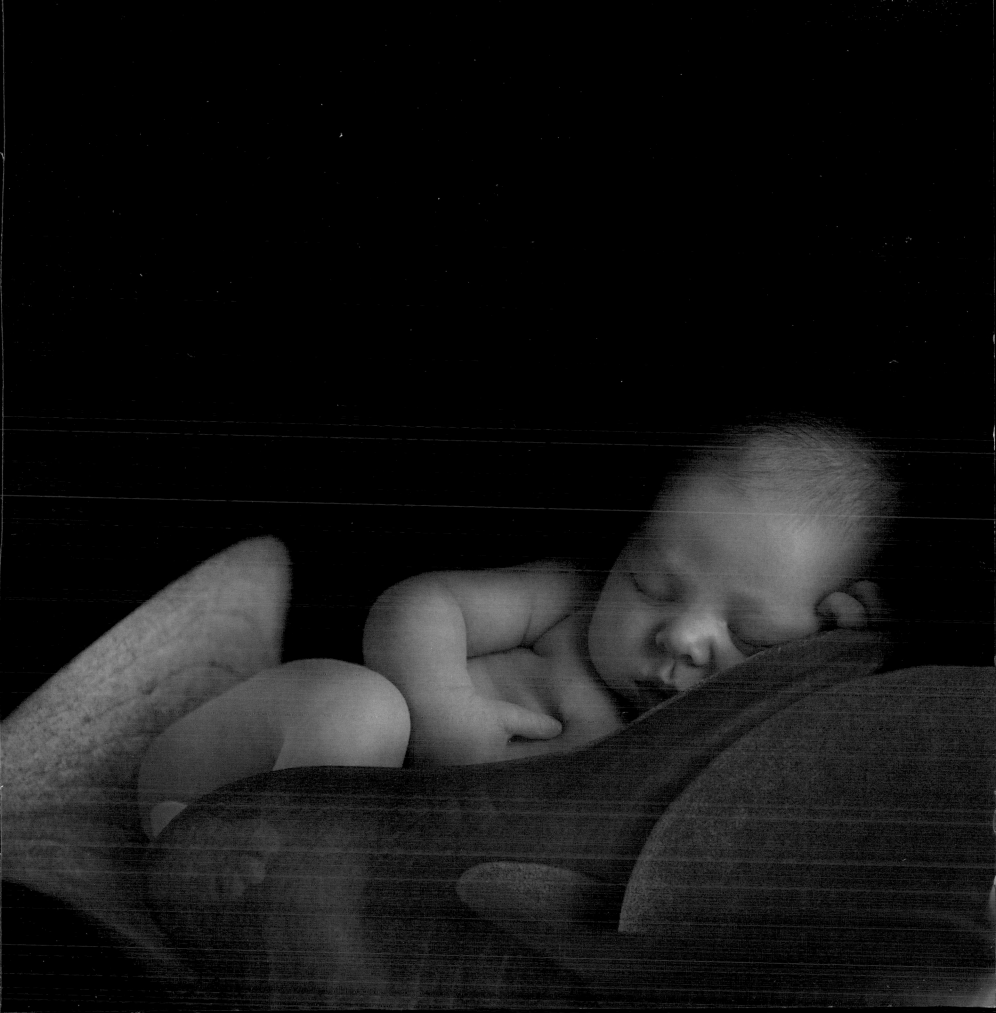

Acknowledgements

The publisher is grateful for the permission to reproduce those items which are subject to copyright. While every effort has been made to trace copyright holders, the publisher would be pleased to hear from any not acknowledged.

About the Quotations

(in alphabetical order by author)

There are two things in life . . .
Josh Billings (1818–1885),
American humorist

A child's world is fresh and new . . .
Rachel Carson (1907–1964),
American writer

Dear, sweet, unforgettable childhood!
Anton Pavlovich Chekhov
(1860–1904), Russian dramatist
and short story writer

An aware parent loves all children . . .
Doc Childre, Founder of the Institute
of HeartMath and author of *A Parenting
Manual, Heart Hope for the Family*

A baby is born with a need to be loved . . .
Frank A. Clark (1911–),
American writer

All my life through, the new sights . . .
Madame Marie Curie (1867–1934),
Polish-born French physicist

The soul is healed by being . . .
Fyodor Dostoevsky (1821–1881),
Russian writer

The finest inheritance you can give . . .
Isadora Duncan (1878–1927),
American dancer

We find delight in the beauty . . .
Ralph Waldo Emerson (1803–1882),
American essayist, poet and philosopher

Mother: the most beautiful word . . .
Kahlil Gibran (1883–1931),
Lebanese poet, philosopher, and artist

There is always one moment in childhood . . .
Graham Greene (1904–1991),
English writer. From *The Power and the
Glory* published by Random House.

It was the tiniest thing I ever decided . . .
Terri Guillemets (1973–),
American quotation anthologist

Children are our most valuable . . .
Herbert Hoover (1874–1964),
31st President of the United States

A mother's arms are made of tenderness . . .
Victor Hugo (1802–1885),
French novelist, poet, and dramatist

Each child is an adventure . . .
Hubert Humphrey (1911–1978),
U.S. Senator and Vice President

To believe in a child is to believe . . .
Henry James (1843–1916),
American novelist

All kids need is a little help . . .
Earvin "Magic" Johnson (1959–),
American basketball player

Children are likely to live up to . . .
Lady Bird Johnson (1912–),
American First Lady

The best and most beautiful things . . .
Helen Keller (1880–1968),
American author

There is a garden in every childhood . . .
Elizabeth Lawrence (1904–1985),
American journalist

All that I am, or hope to be . . .
Abraham Lincoln (1808–1865),
16th President of the United States

You cannot catch a child's spirit . . .
Arthur Miller (1915–2005),
American playwright

Babies are always more trouble . . .
Charles Osgood (1933–),
American newscaster and writer

When I approach a child . . .
Louis Pasteur (1822–1895),
French chemist

If the family were a container . . .
Letty Cottin Pogrebin (1939–),
American writer

We cannot always build the future . . .
Franklin D. Roosevelt (1882–1945),
32nd President of the United States

The family is one of nature's masterpieces.
George Santayana (1863–1952),
Spanish-born American philosopher

Anything can happen, child . . .
Shel Silverstein (1930–1999),
American composer, artist and writer

Children are our immortality . . .
Alfred North Whitehead (1861–1947),
English philosopher and mathematician

Children are the living messages . . .
John W. Whitehead (1946–),
American writer

Once you bring a life into the world . . .
Elie Wiesel (1928–), Romanian-born
American writer

ANNE GEDDES ®

www.annegeddes.com

First published in 2005 by Photogenique Publishers
(a division of Hachette Livre NZ Ltd)
4 Whetu Place, Mairangi Bay, Auckland, New Zealand

This edition published in North America, United Kindom, and
Republic of Ireland in 2005
by Andrews McMeel Publishing,
an Andrews McMeel Universal company,
4520 Main Street, Kansas City, Missouri 64111-7701

Produced by Kel Geddes
Printed in China by Midas Printing Limited, Hong Kong

ISBN-13: 978-0-7407-5573-6

ISBN-10: 0-7407-5573-0

ANNE GEDDES

Cherished Thoughts with Love

I had always imagined that there would be so few words to adequately describe how I feel about babies, which is why I have spent the past 25 years photographing them, not daring to put pen to paper. I am touched by their infinite, delicate beauty, their enormous potential, their unique personalities from the minute they are born, and the overwhelming sense of responsibility parents feel from the minute they first cradle their tiny newborn.

And yet upon researching for this book, I discovered a whole range of delightful quotes and observations, which I felt did the job perfectly! A few of my favorites are included in this book—some are funny, some thoughtful, some very insightful, and quite a few brought a lump to my throat. Interesting, too, that a number of the observations are very old—the earliest penned circa AD125.

Through the ages, thankfully, little seems to have changed in relation to the way we cherish our children.

Anne Geddes

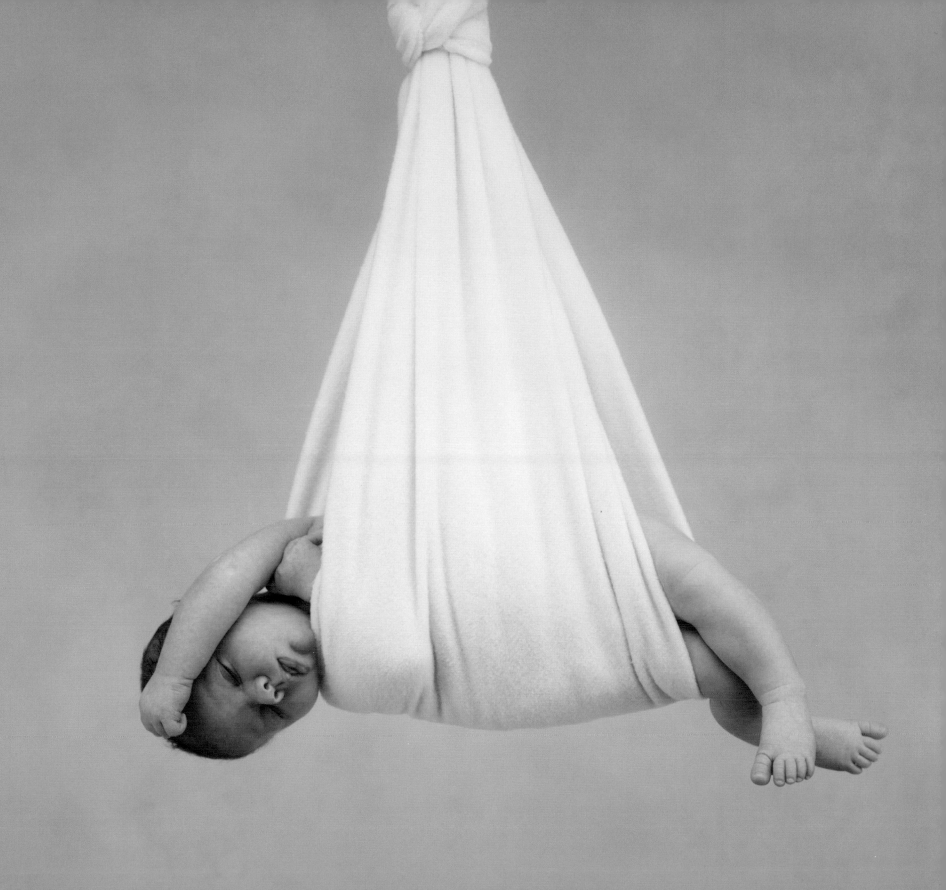

Love is a fruit in season at all times,
and within reach of every *hand*.

Mother Teresa (1910–1997)

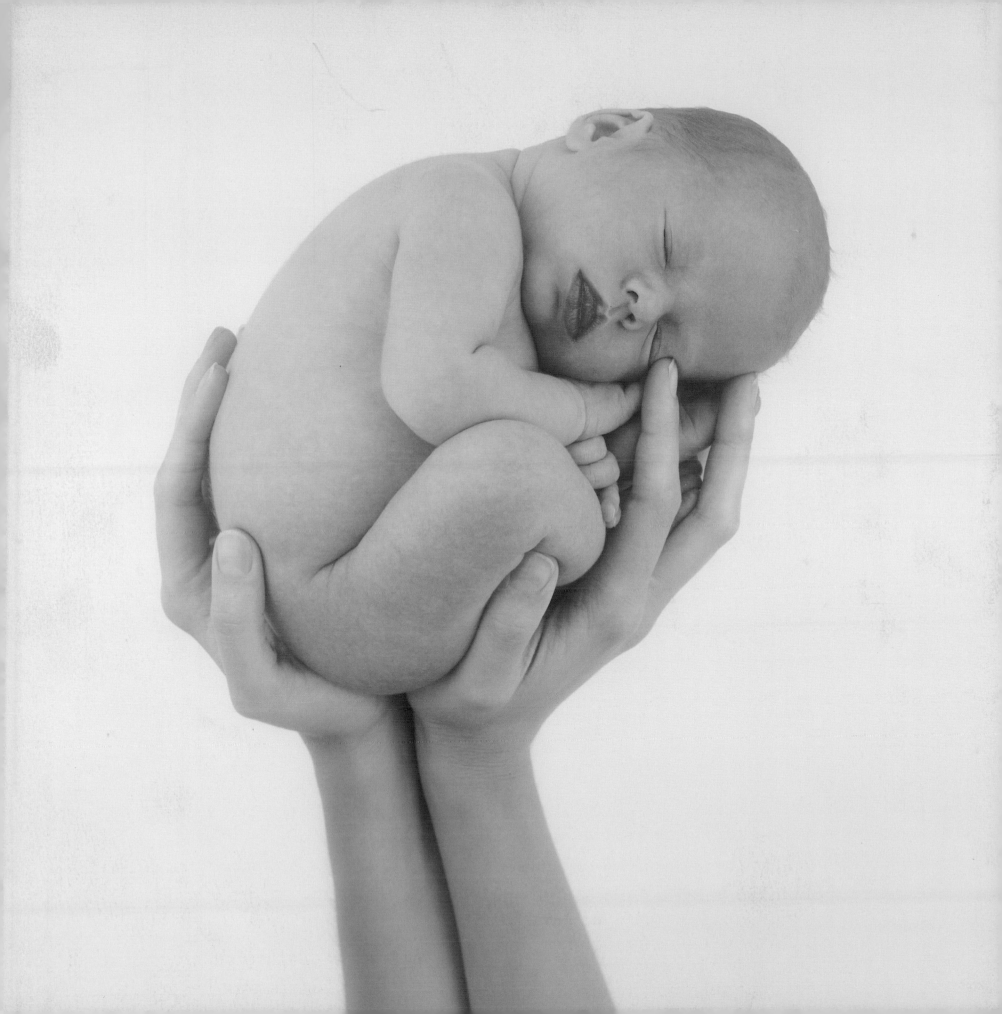

We find delight in the *beauty*

and happiness of children

that makes the *heart* too big

for the body.

Ralph Waldo Emerson (1803–1882)

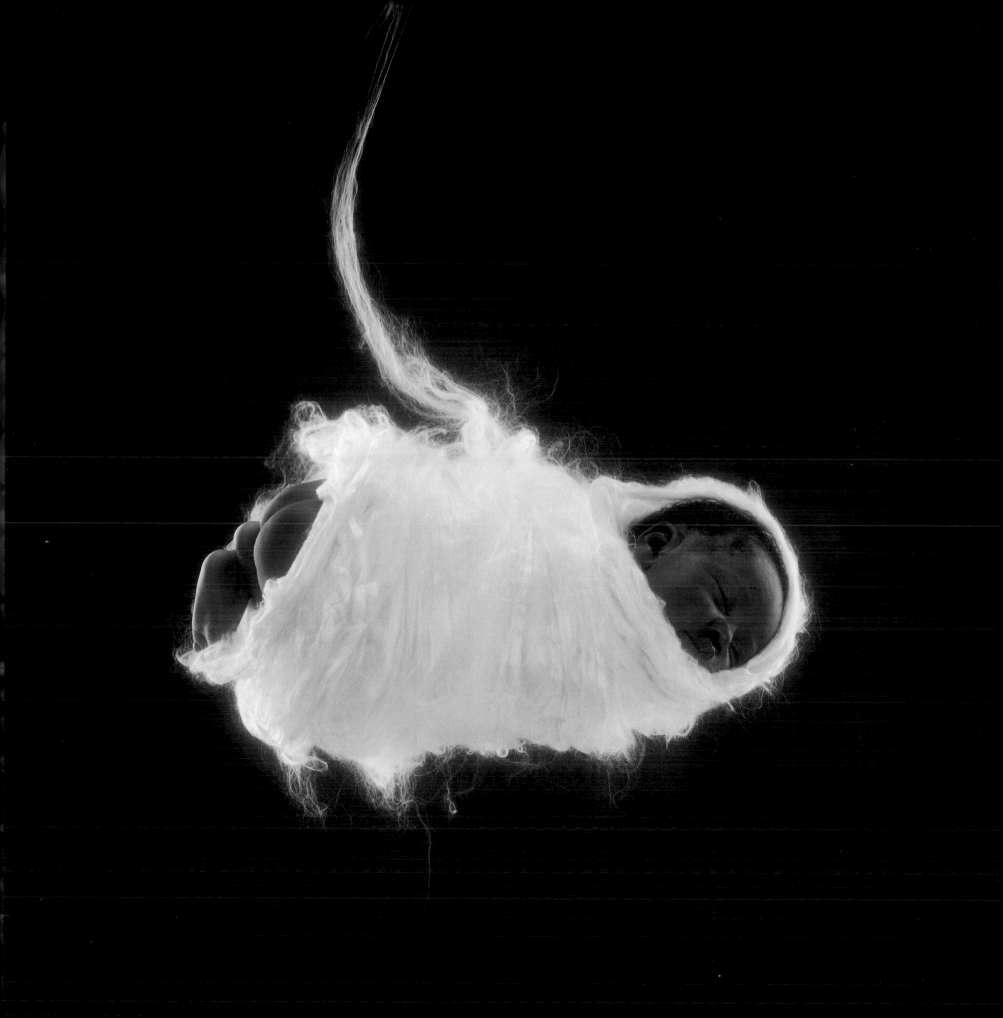

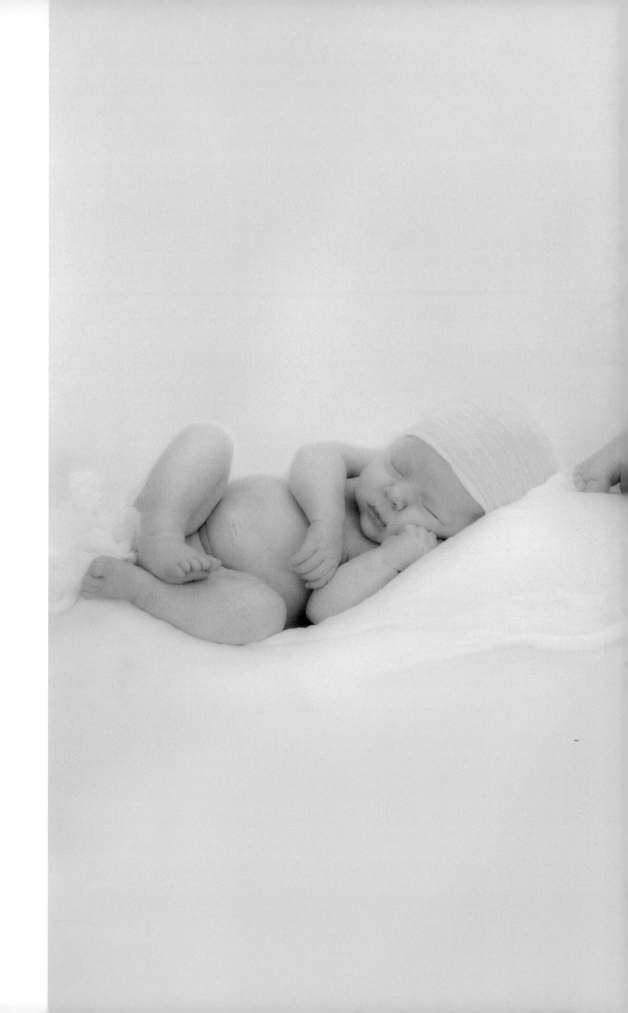

The *soul*

is *healed*

by being with

children.

Fyodor Dostoevsky (1821–1881)

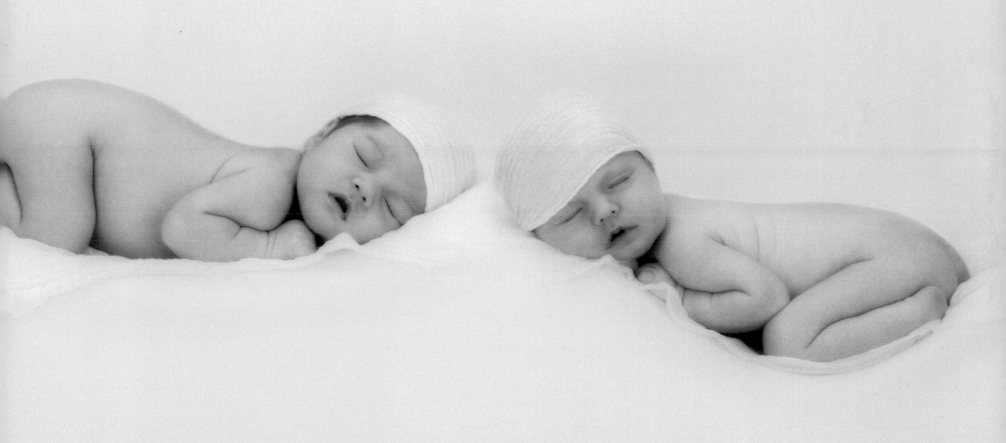

Each child is an adventure into a better life—an opportunity to change the old pattern and make it new.

Hubert Humphrey (1911–1978)

Children are our immortality; in them we see the story of our life rewritten in a fairer hand.

Alfred North Whitehead (1861–1947)

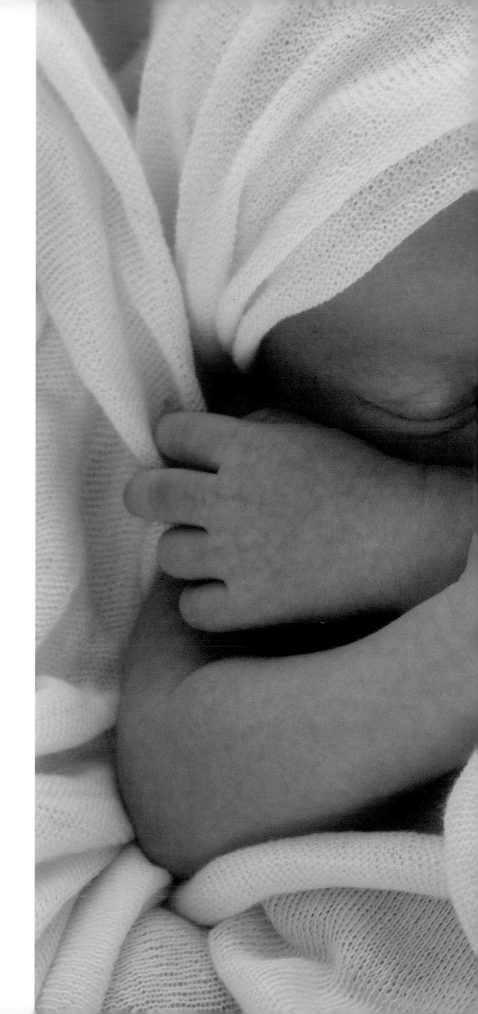

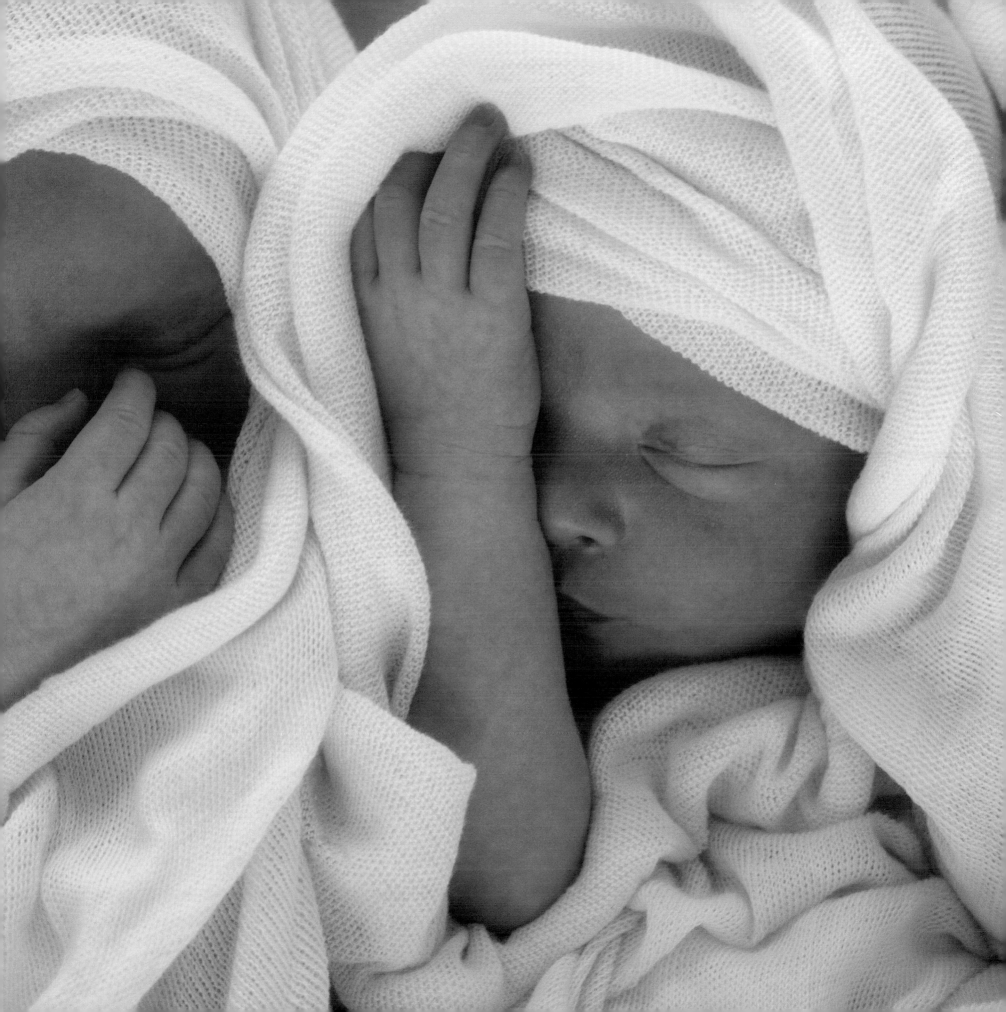

An aware parent *loves*
all *children* he or she meets and
interacts with—for you are a *caretaker*
for those *moments* in time.

Doc Childre

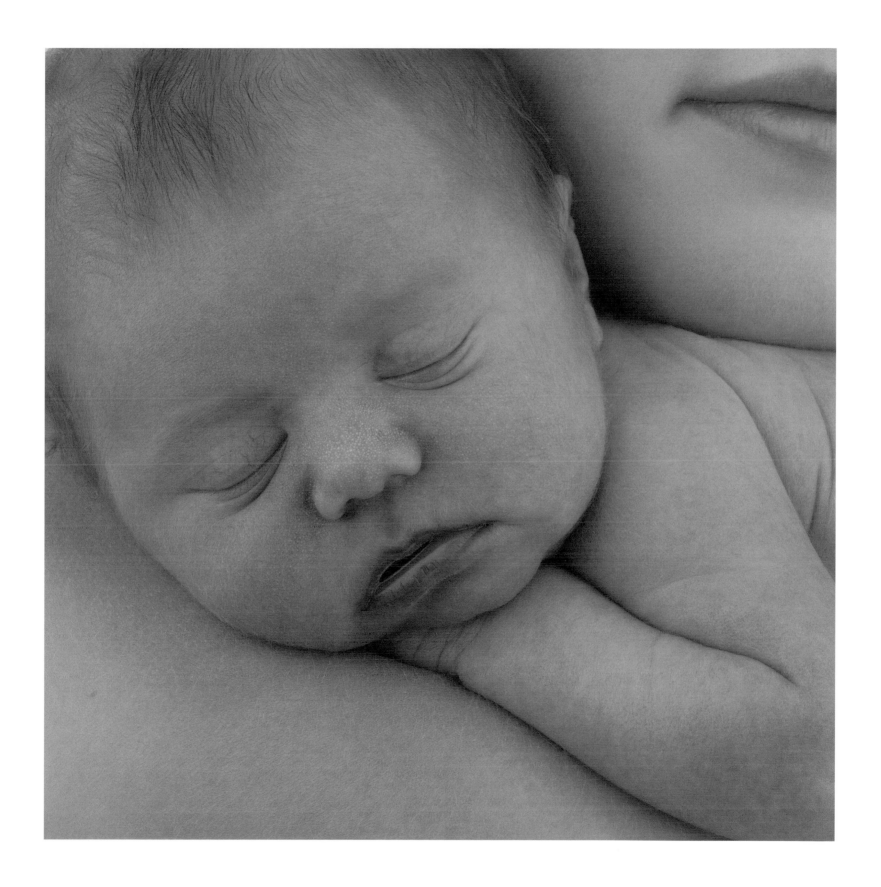

Once you bring

a life into the world

you must *protect* it.

We must protect it by

changing the world.

Elie Wiesel (1928–)

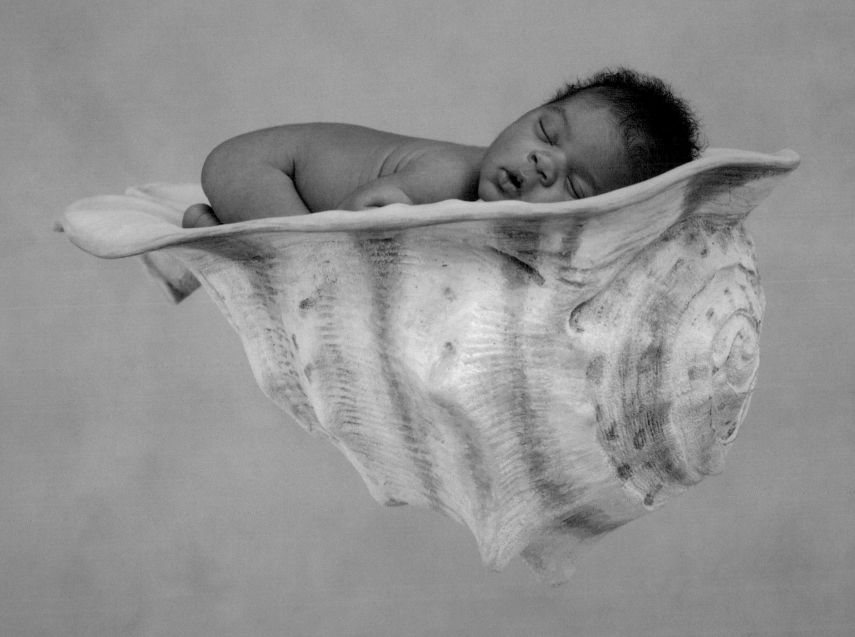

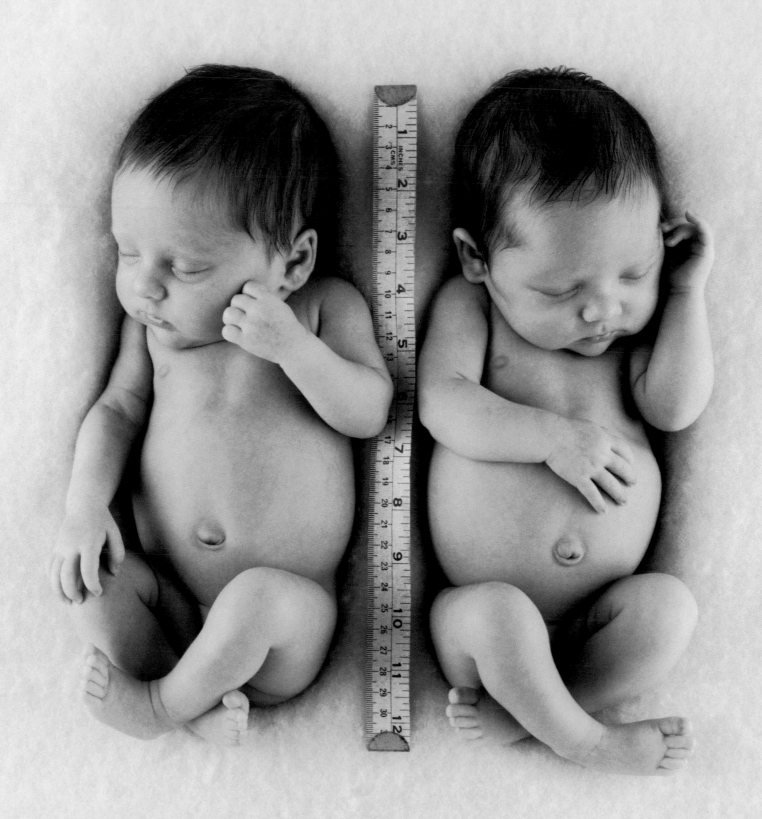

Children are one third of our population and all of our *future*.

Select Panel for the Promotion of Child Health, 1981

Children are love made visible.

American proverb

Children are likely

to live up to what you

believe in them.

Lady Bird Johnson (1912–)

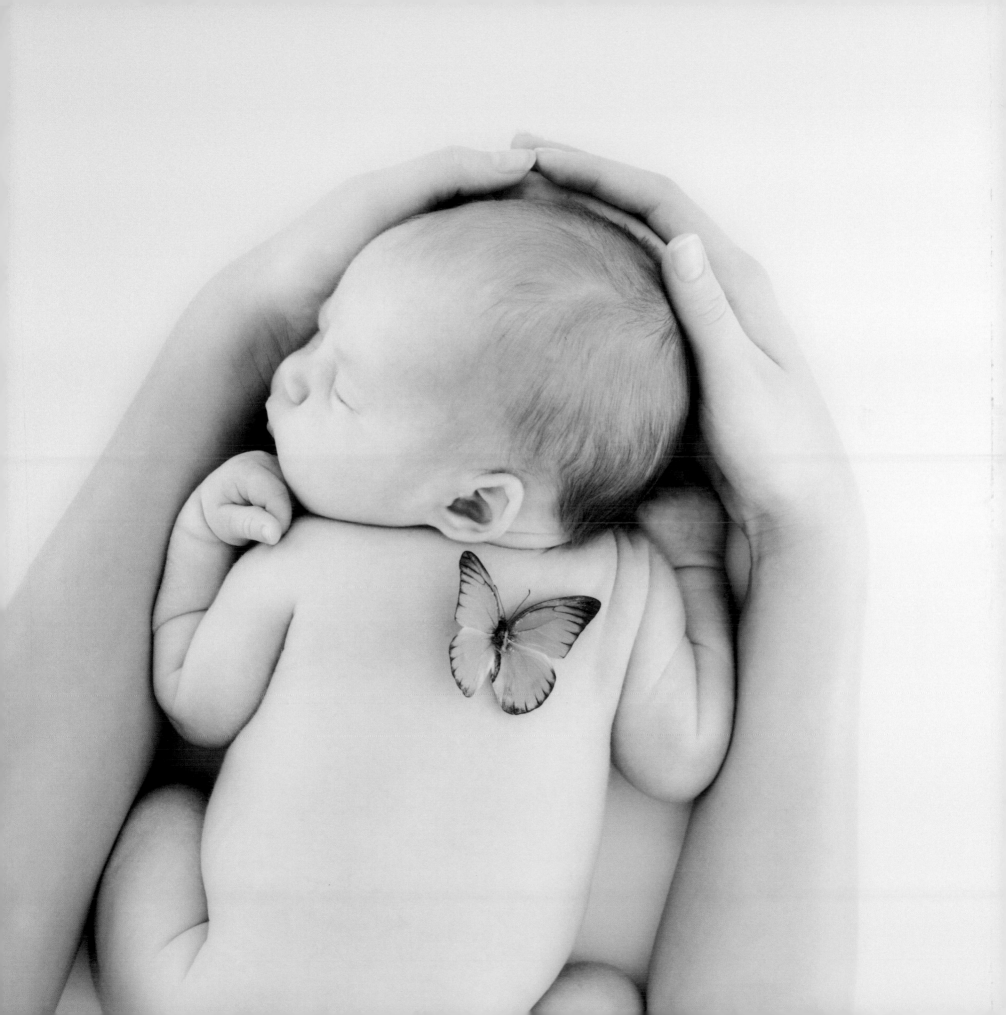

There are no *seven* wonders

of the world in the eyes of a child.

There are seven *million*.

Walt Streightiff

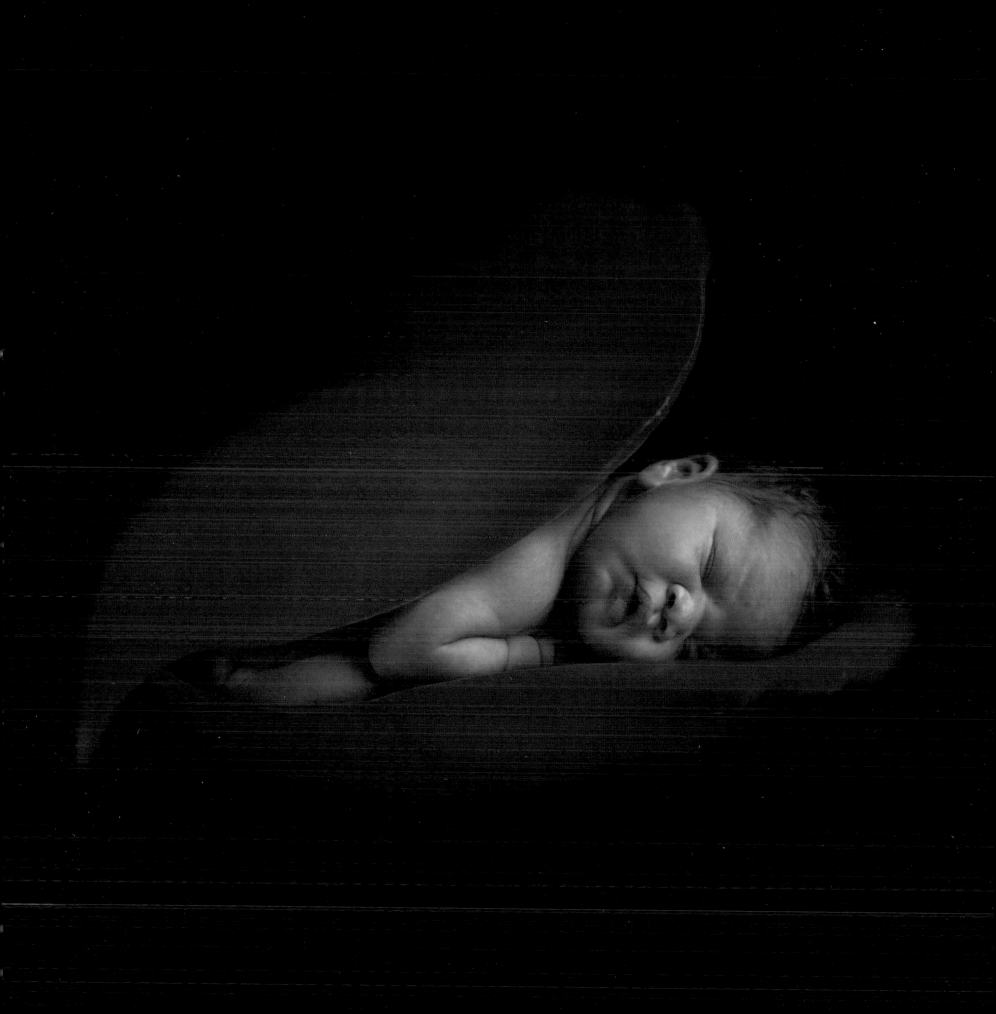

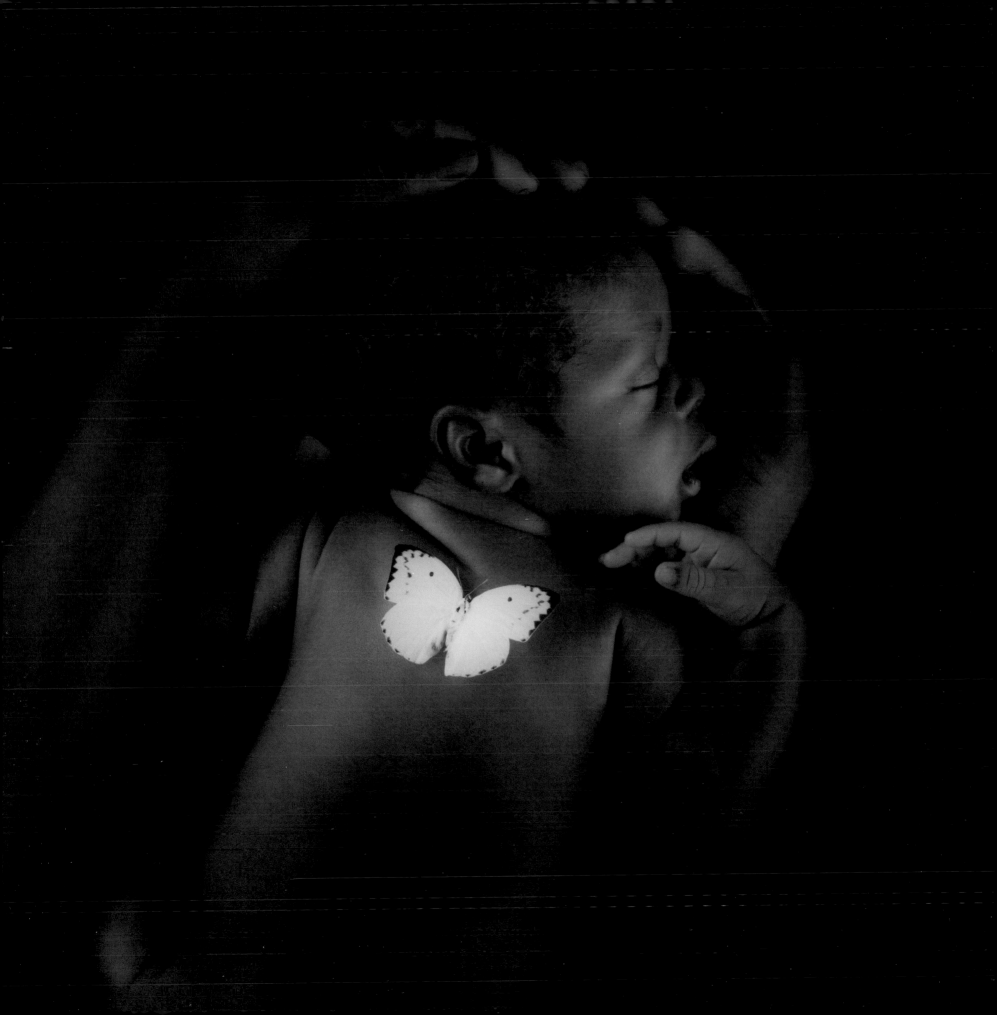

*A mother's
children
are portraits
of herself.*

Author unknown

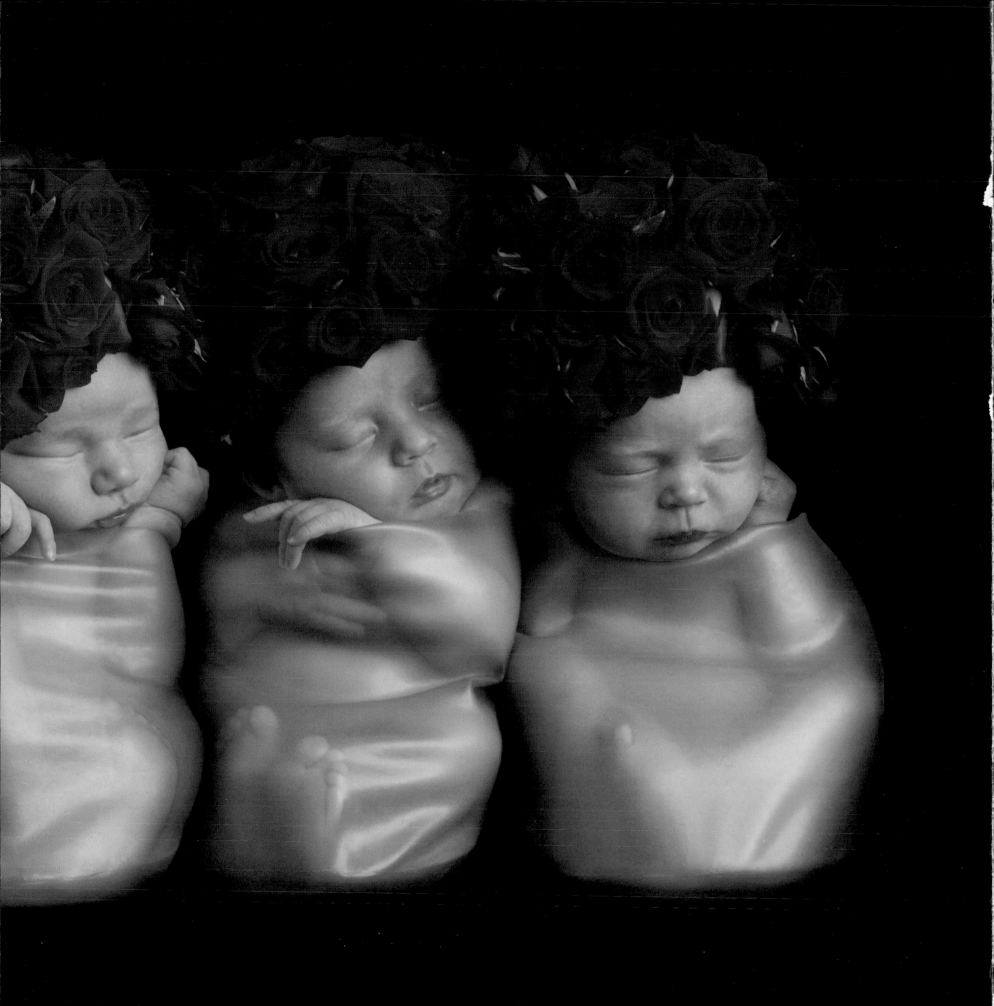

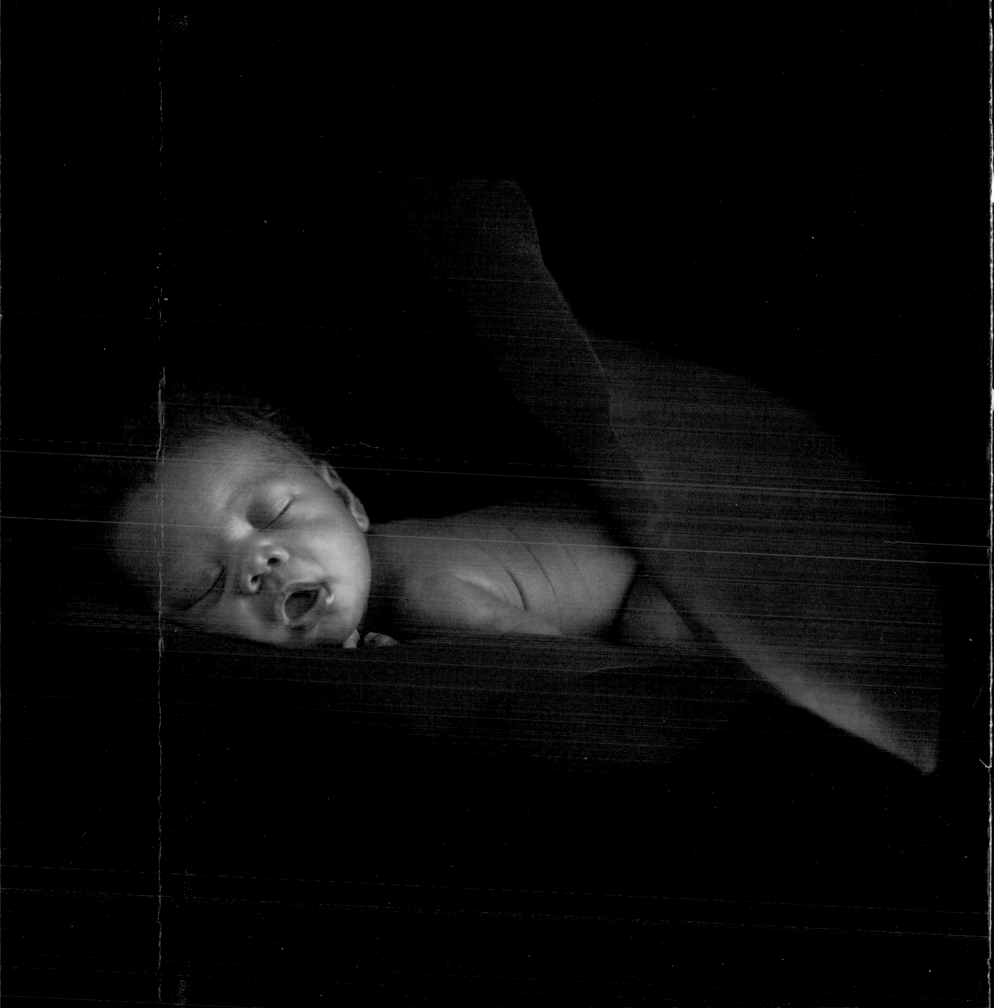

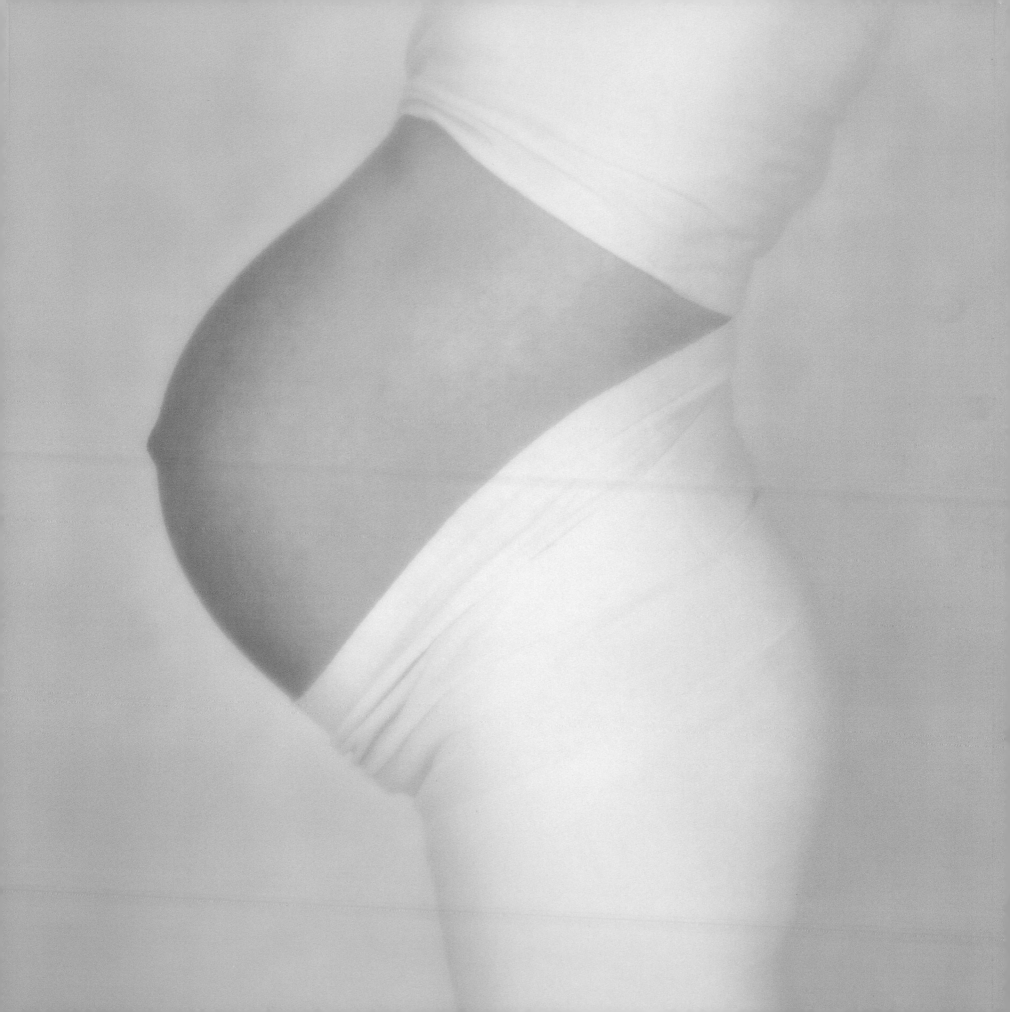

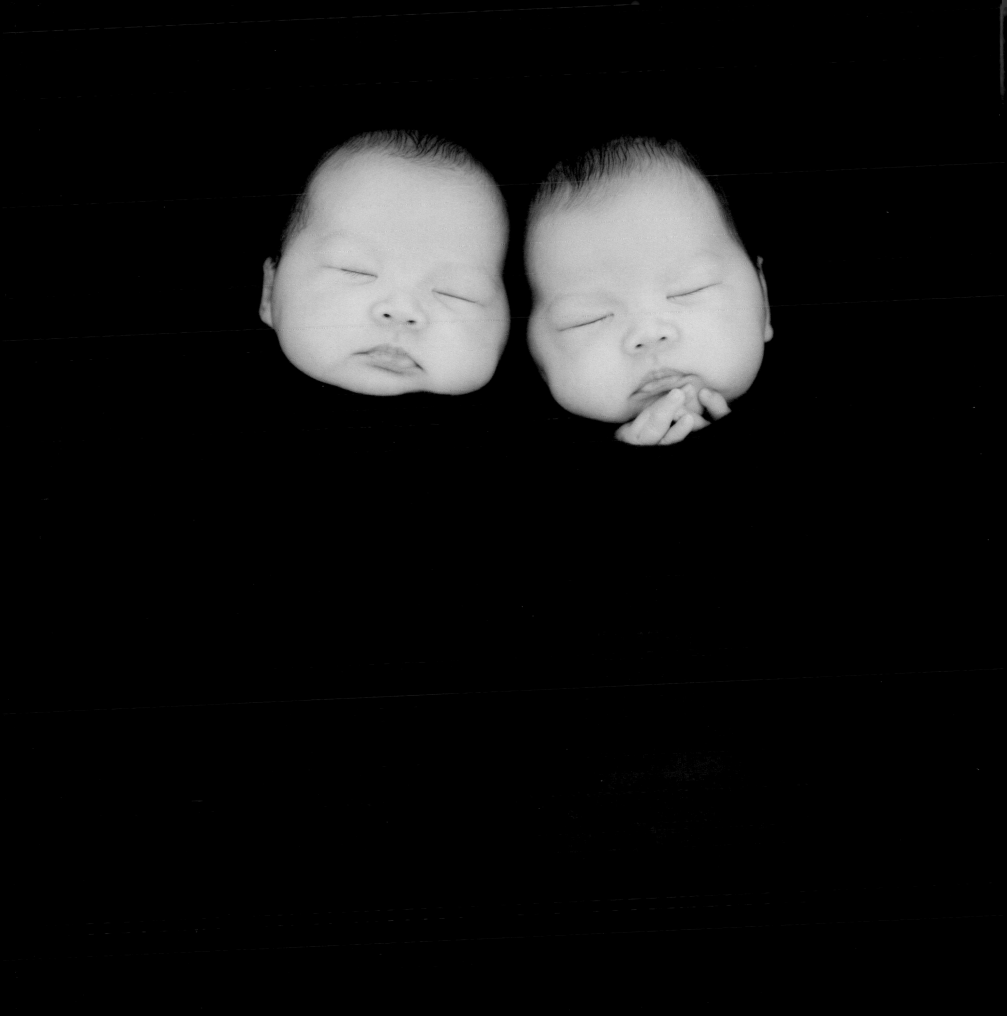

On the night you were *born*, every *star*, in every *sky*,

Shone down in *jealousy*, at the *twinkle* in your eye.

Craig Castle

It was the *tiniest thing* I ever decided to put my *whole life* into.

Terri Guillemets (1973–)

To *heir* is *human*.

Dolores E. McGuire

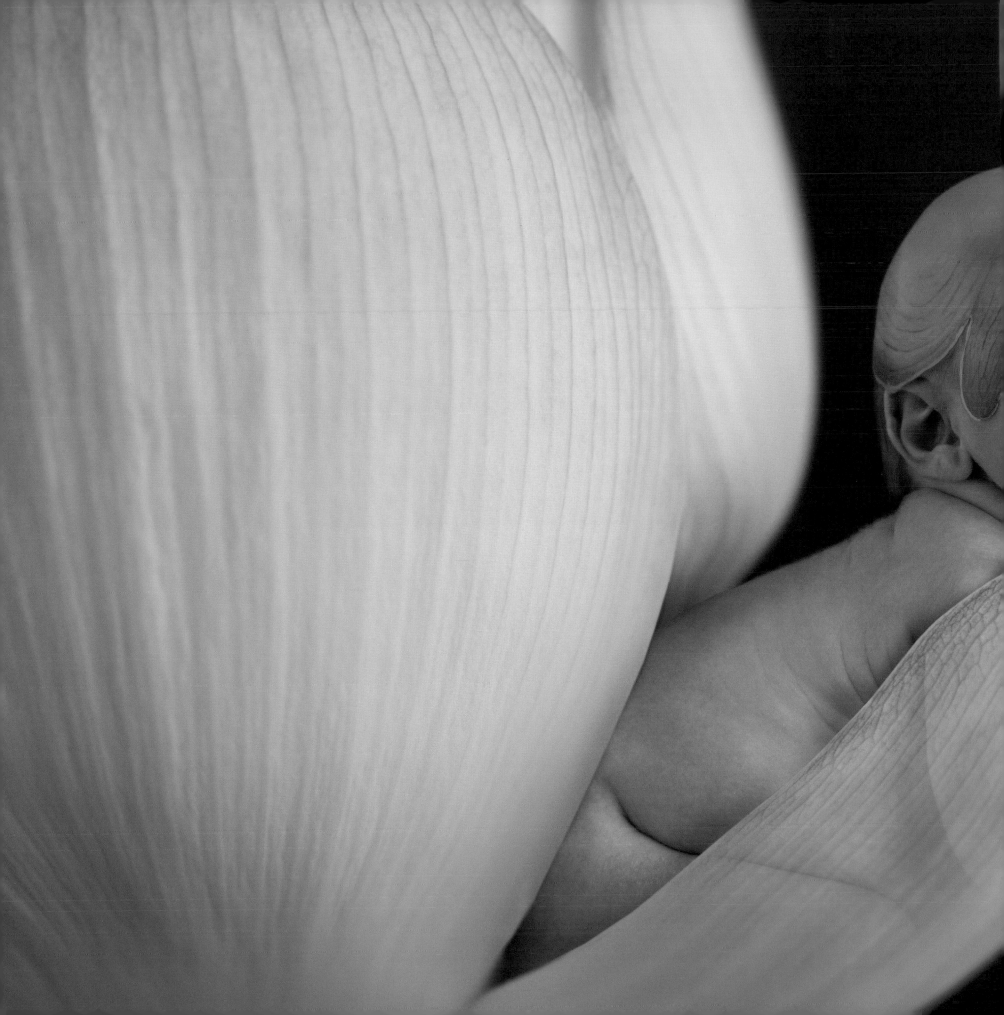

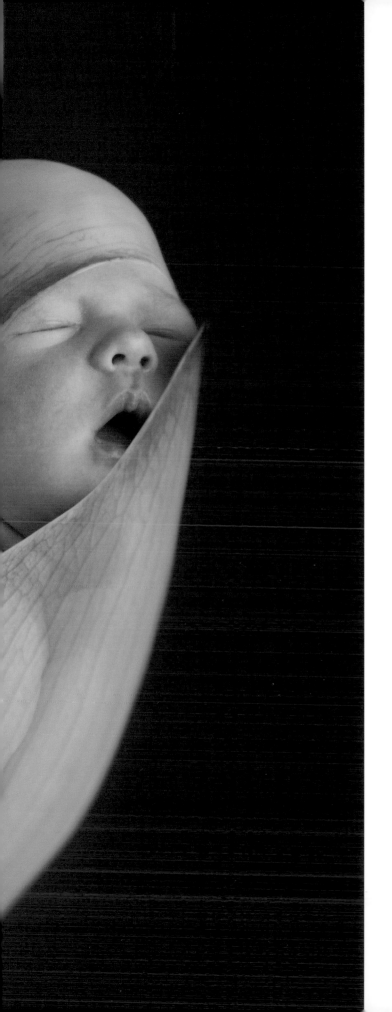

Every baby needs a lap.

Henry Robin

All kids need is a little *help*, a little *hope*

and somebody who *believes* in them.

Earvin "Magic" Johnson (1959–)

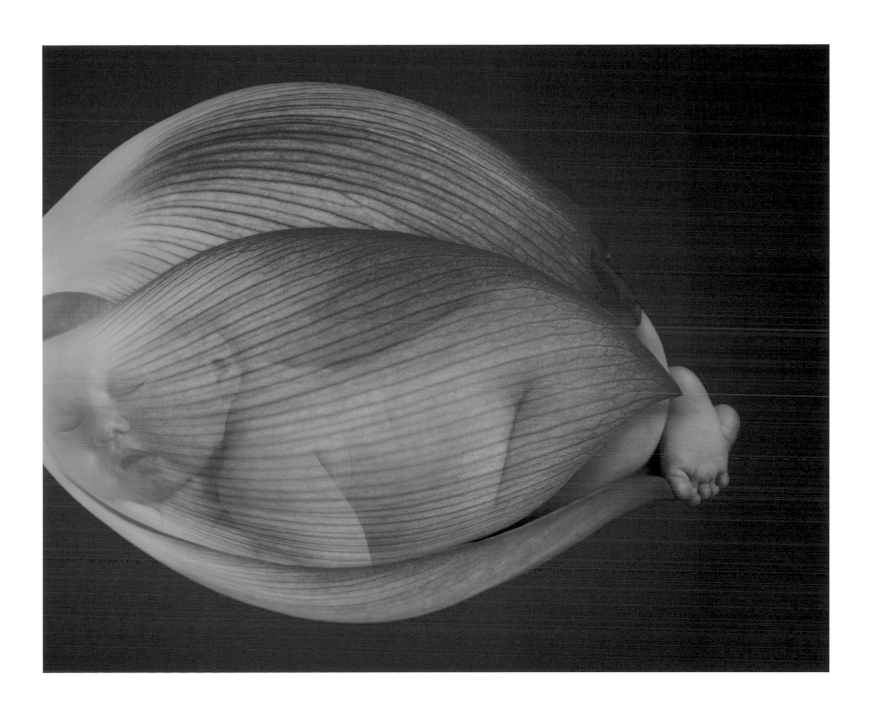

Mother: the most beautiful word

on the lips of *mankind*.

Kahlil Gibran (1883–1931)

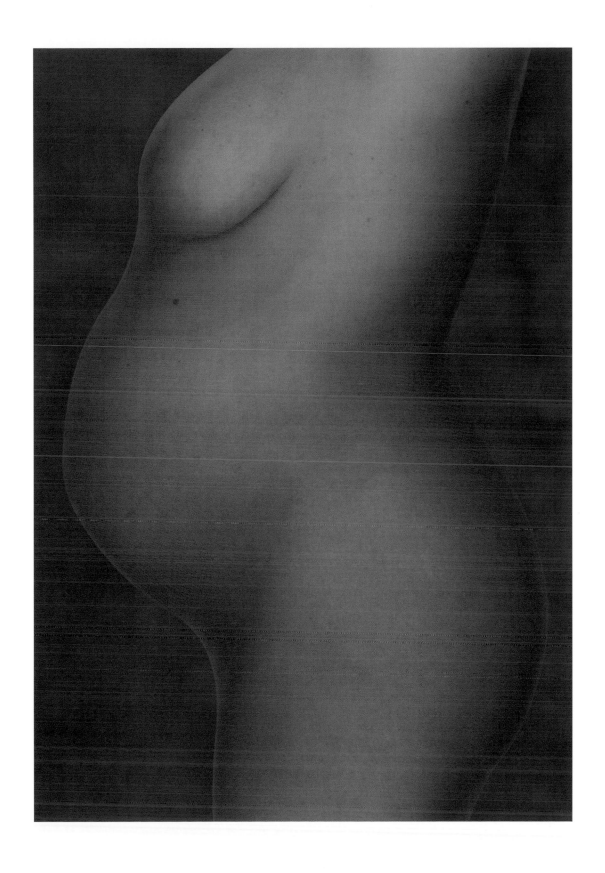

You cannot catch a

child's spirit

by running after it;

you must stand still

and for love

it will soon itself return.

Arthur Miller (1915–2005)

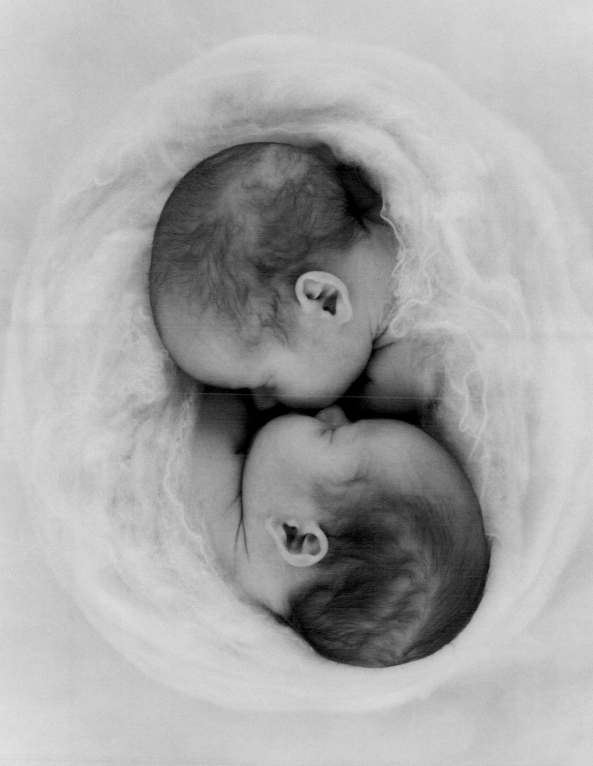

Dear, sweet,

unforgettable

childhood!

Anton Pavlovich Chekhov (1860–1904)

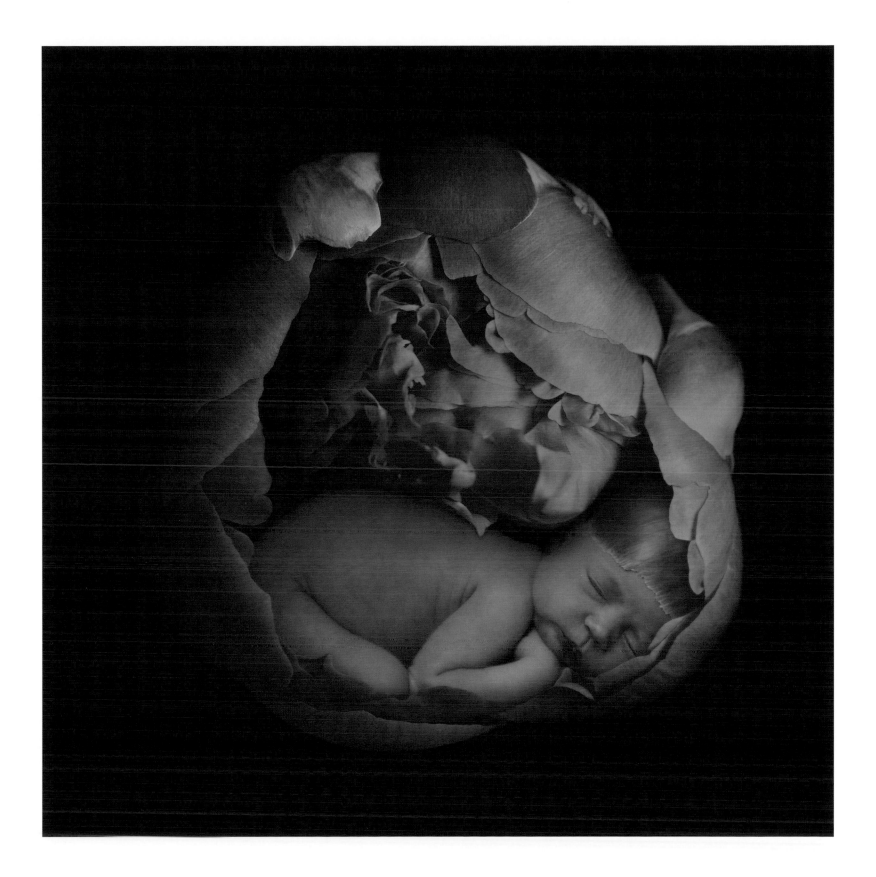

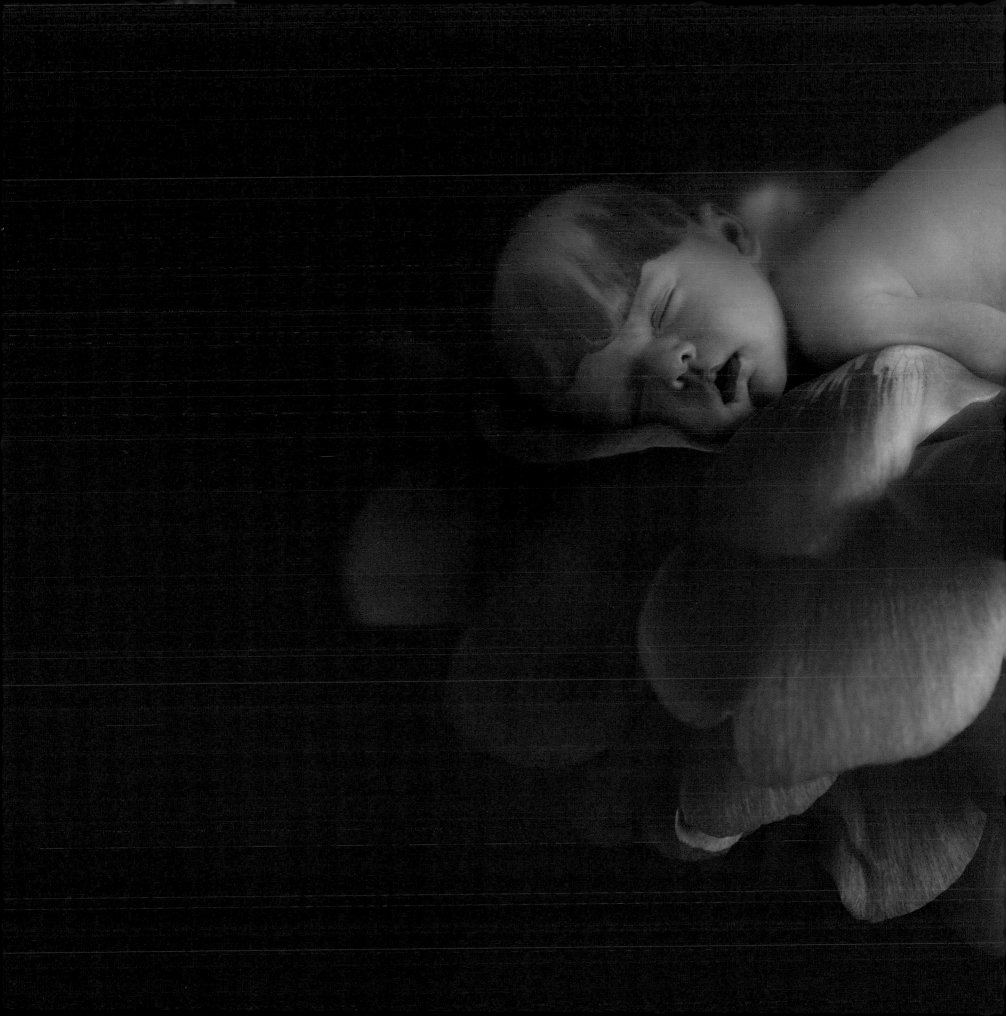

The *best* and most *beautiful*

things in the world cannot

be *seen* or even *touched*.

They must be felt with the heart.

Helen Keller (1880–1968)

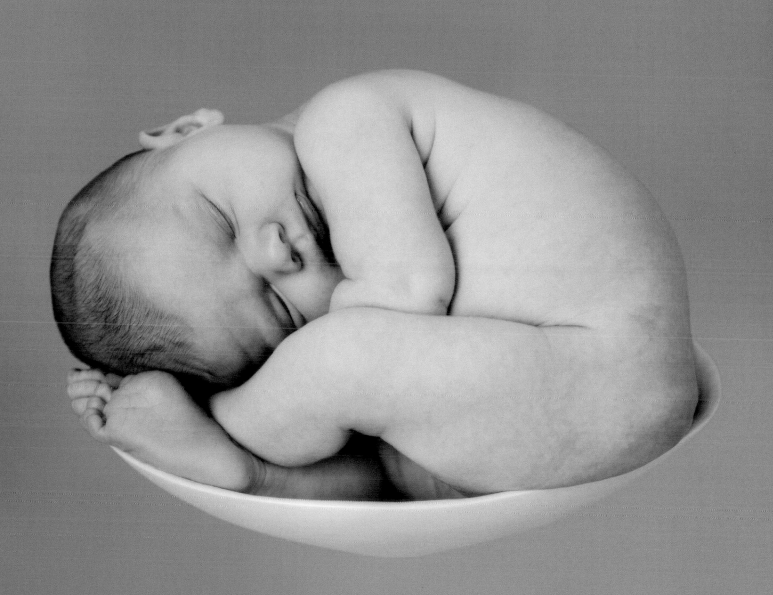

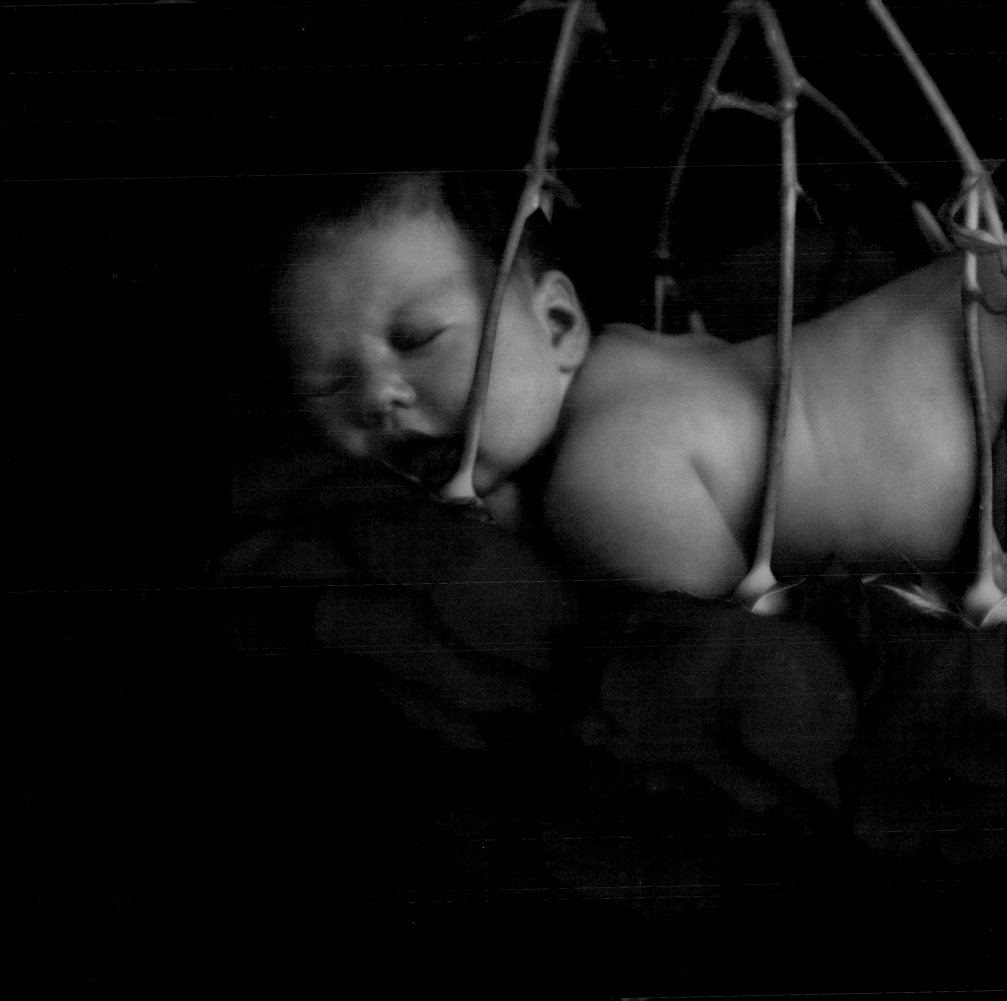

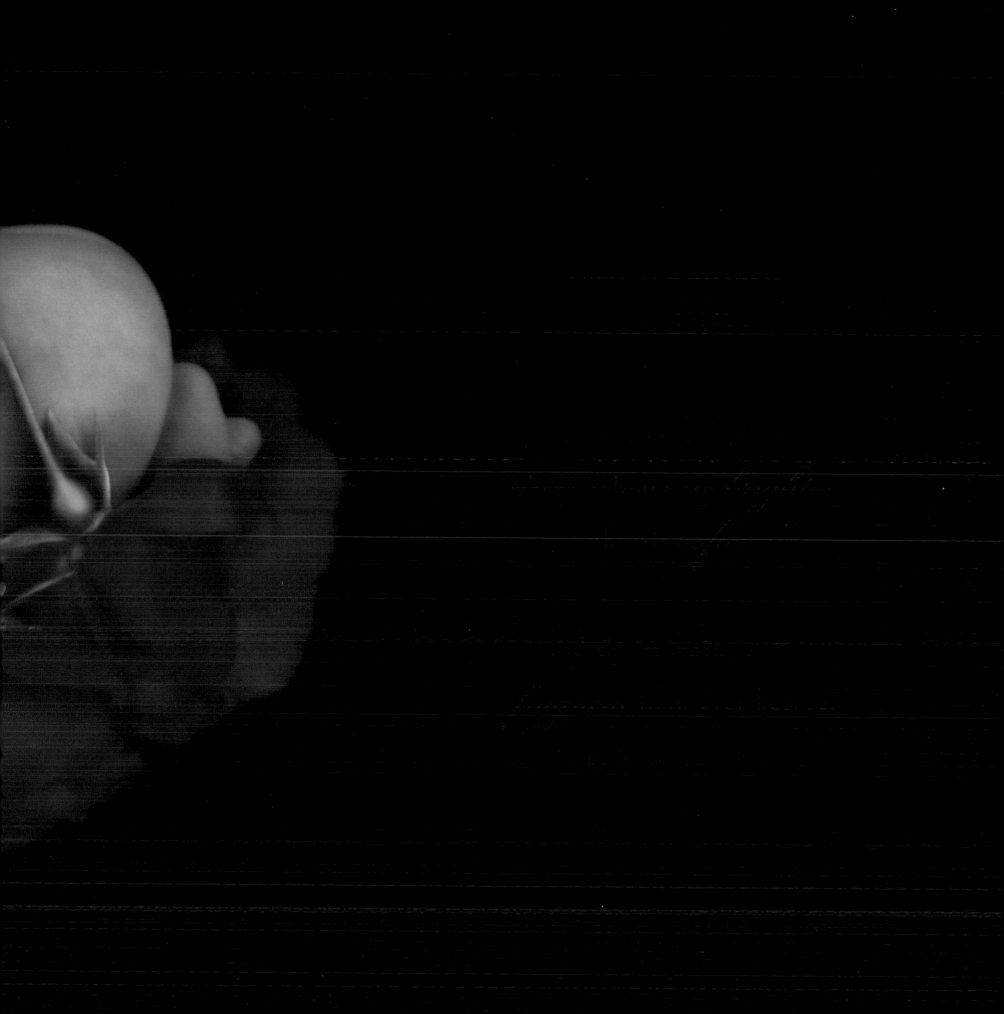

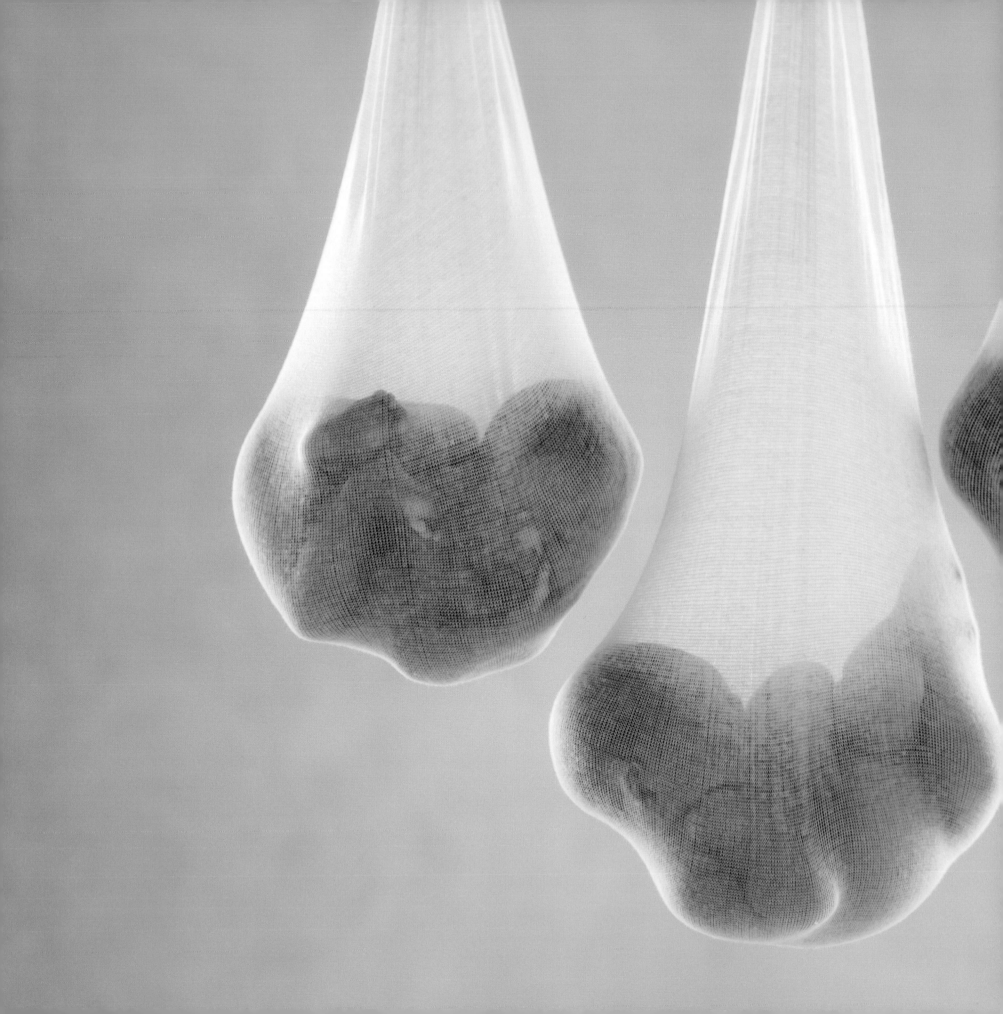

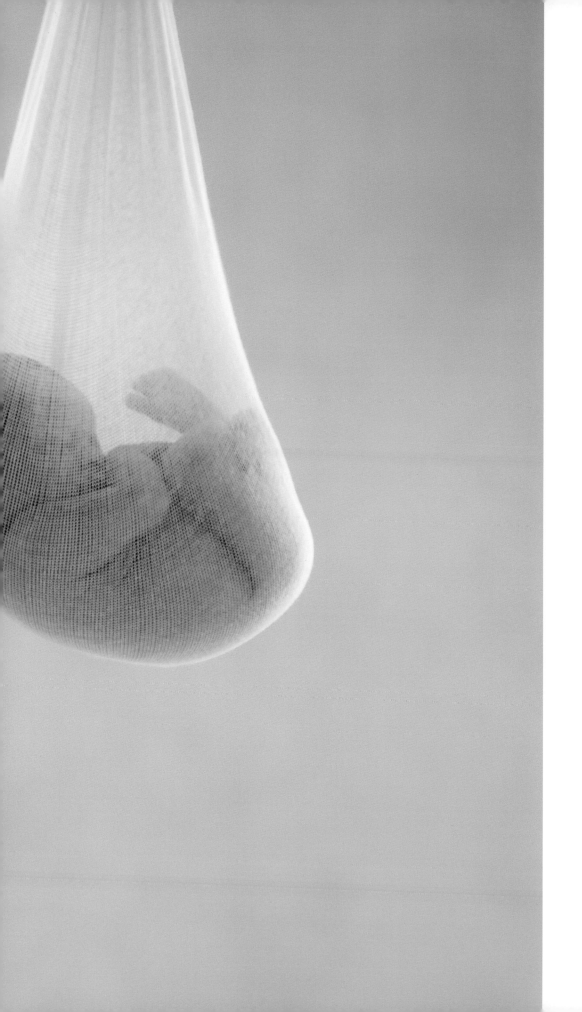

Be gentle with the young.

Juvenal (AD55–127)

Children are only *young* once.

Polish proverb

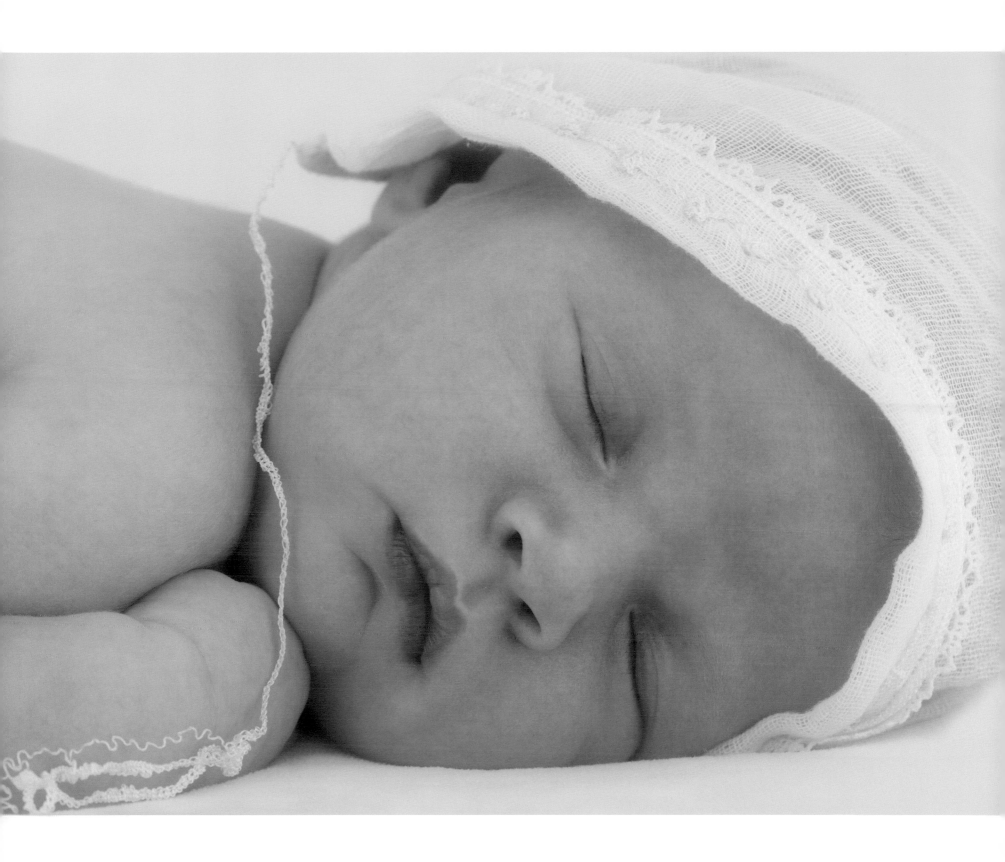

If the family were a container,

it would be a *nest*,

an *enduring* nest,

loosely woven,

expansive, and *open*.

Letty Cottin Pogrebin (1939–)

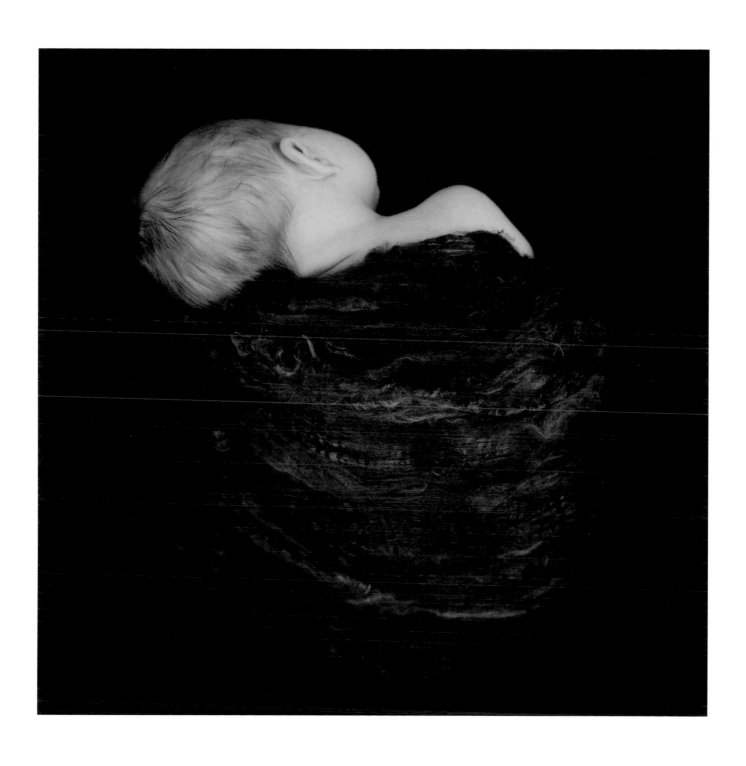

The finest *inheritance* you can give a child

is to allow it to make its ***own way***,

completely on its own feet.

Isadora Duncan (1878–1927)

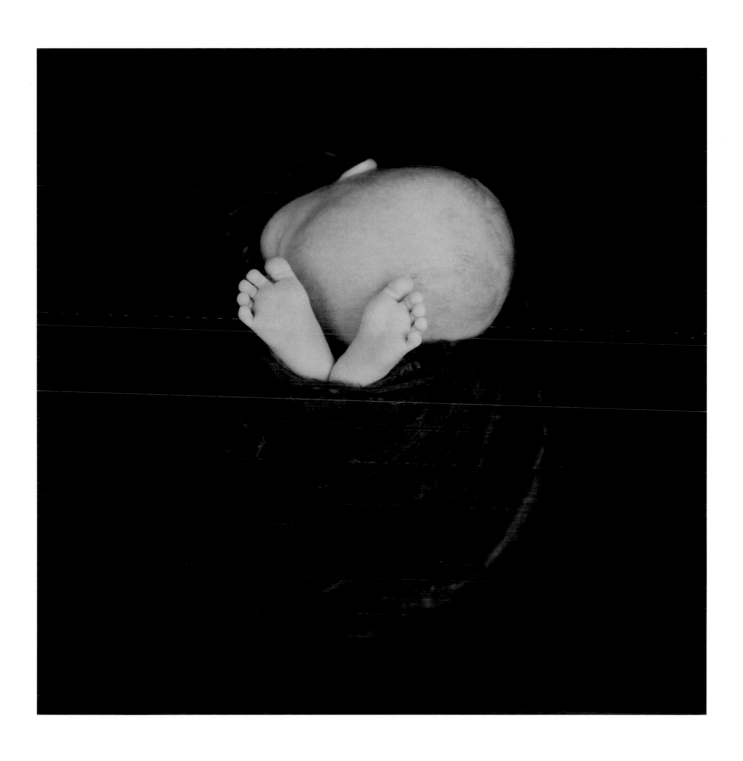

Children are our most *valuable* natural resource.

Herbert Hoover (1874–1964)

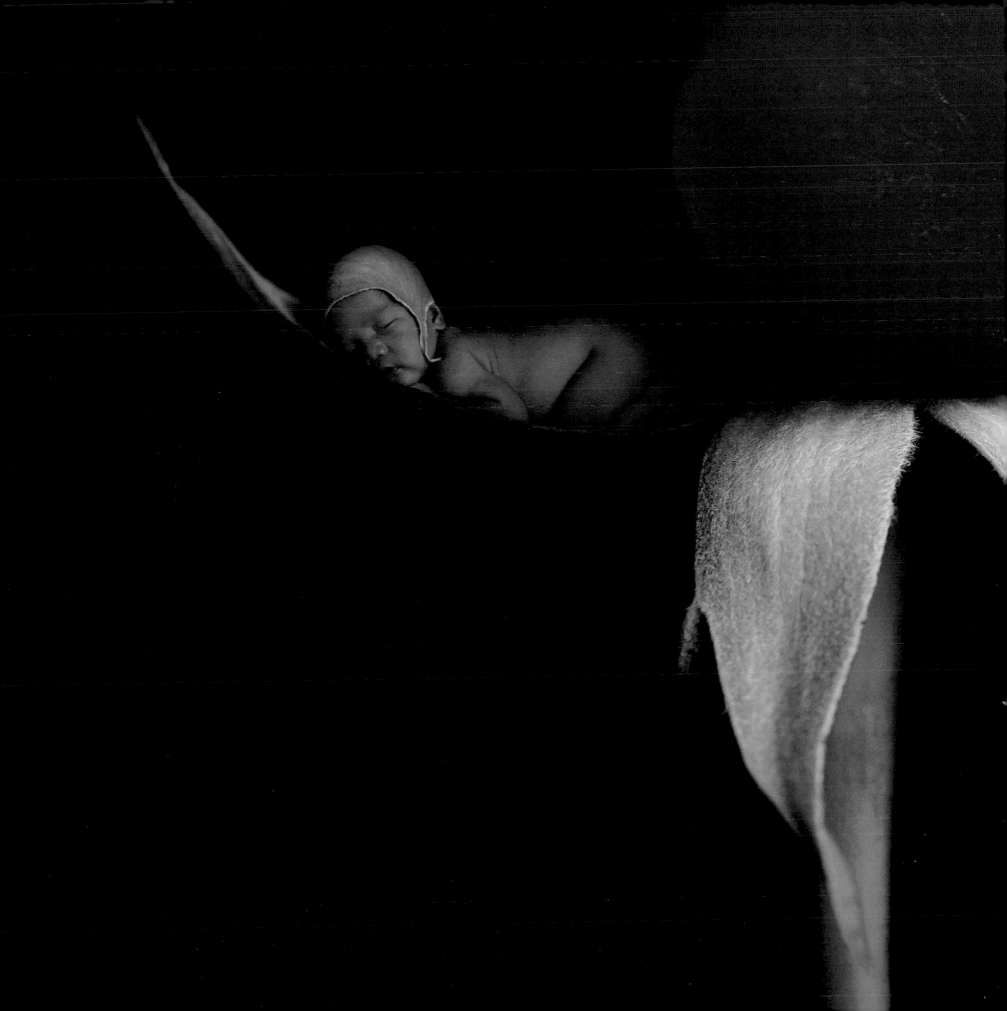

We cannot always
build the *future*
for our youth,
but we can build
our *youth*
for the future.

Franklin D. Roosevelt (1882–1945)

When you were born,

you cried

and the world rejoiced.

Native American proverb

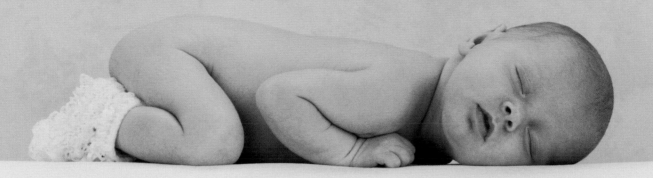

Milly
Olivia Rose

6 lbs 10 oz

When I approach a child,
he inspires in me two sentiments:
tenderness for what he is,
and respect for what he may become.

Louis Pasteur (1822–1895)

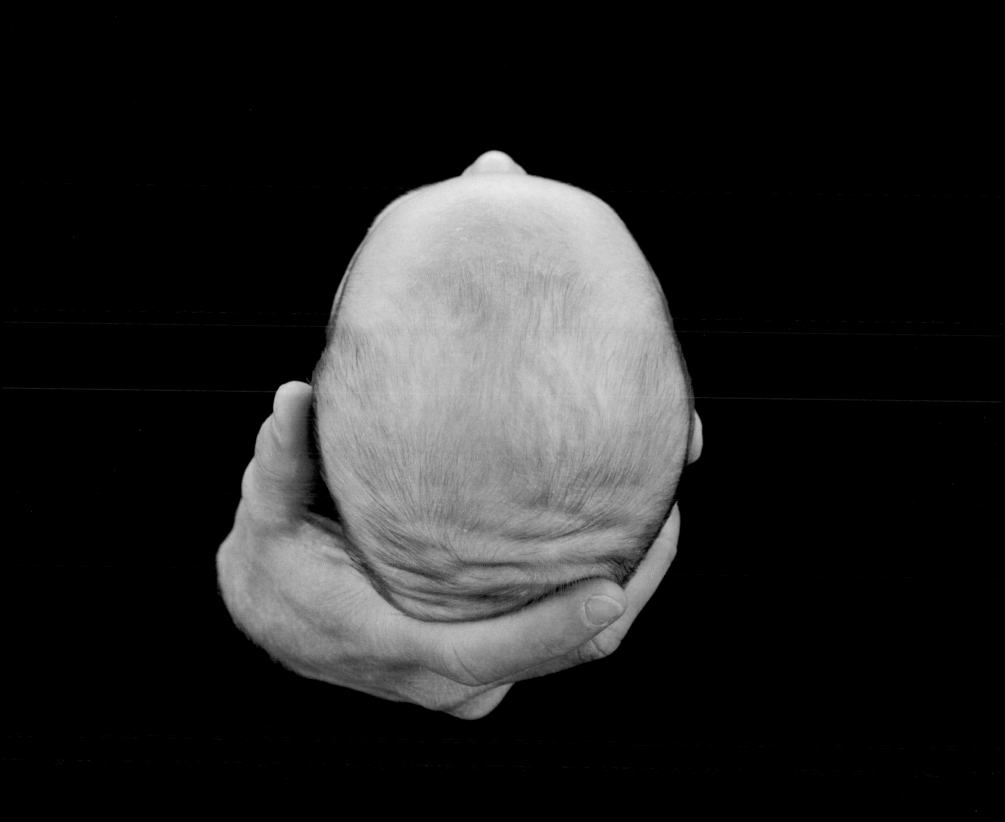

A child's world

is fresh

and new

and beautiful,

full of wonder

and excitement.

Rachel Carson (1907–1964)

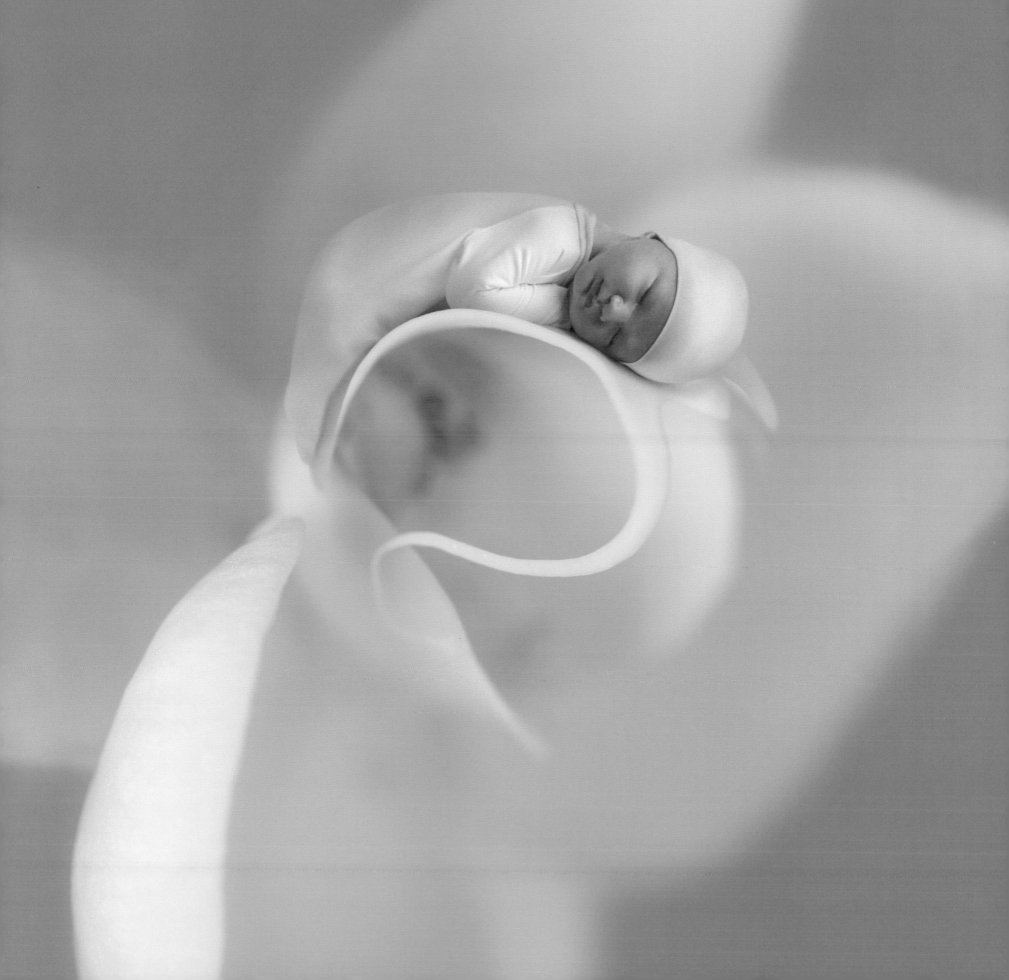

Before you were conceived

I wanted you

Before you were born

I loved you

Before you were here an hour

I would die for you

This is the miracle of life.

Maureen Hawkins

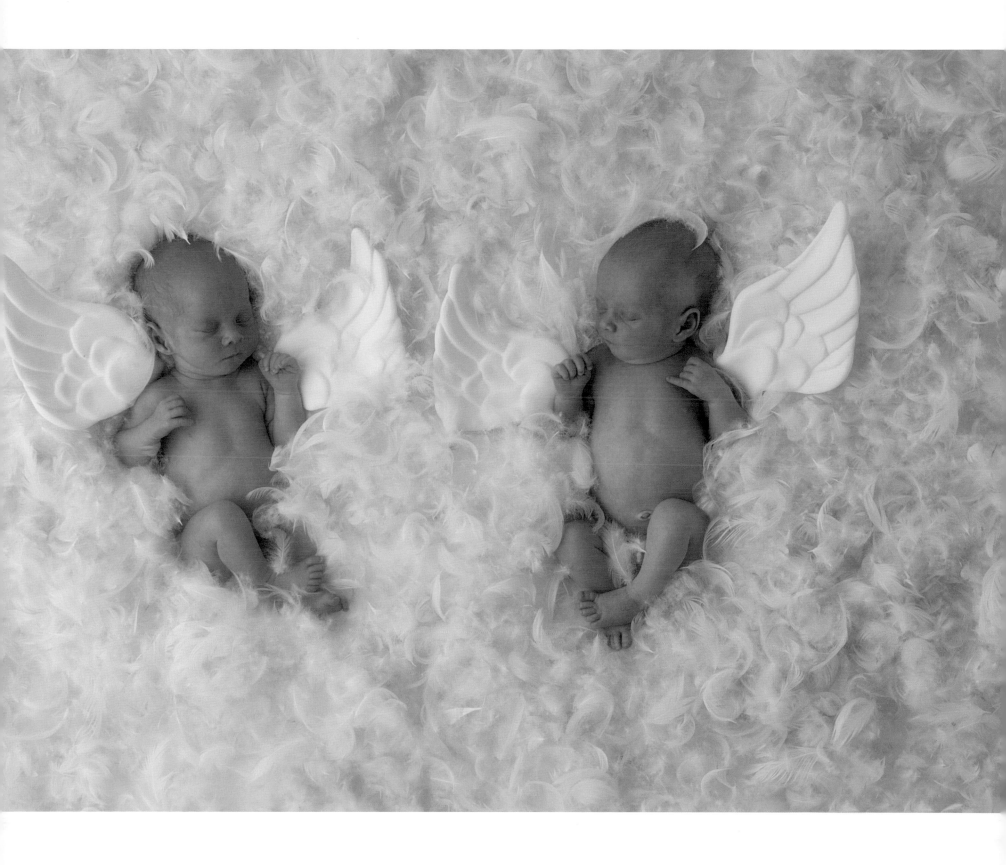

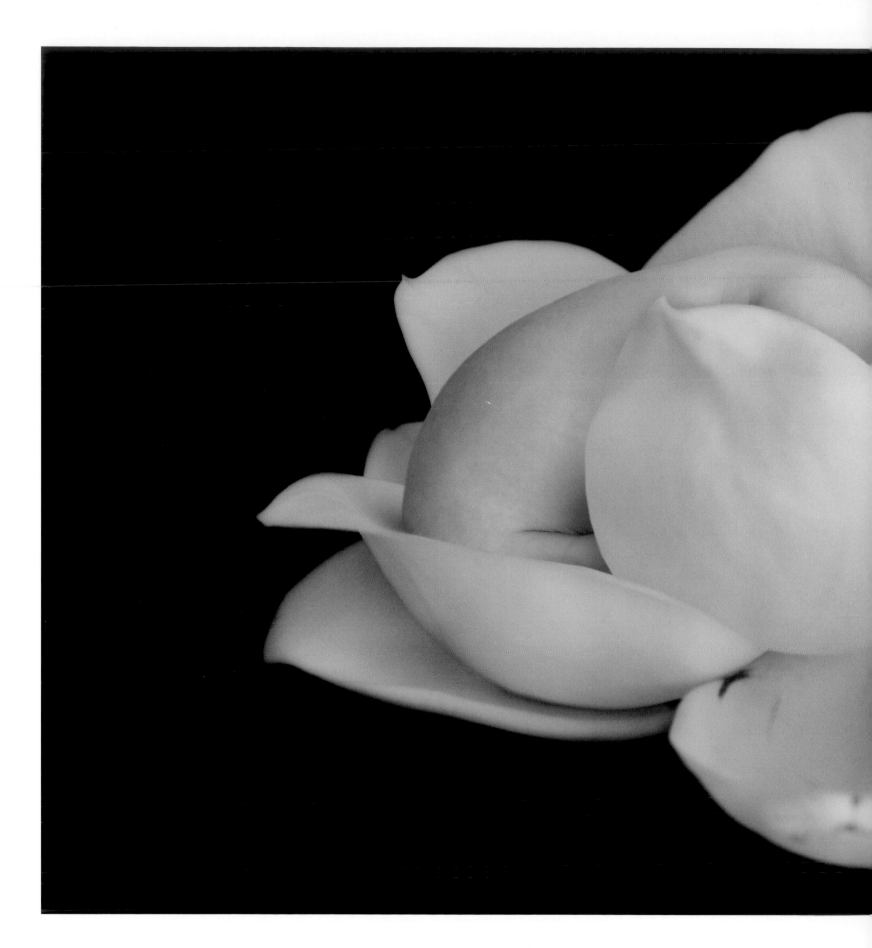

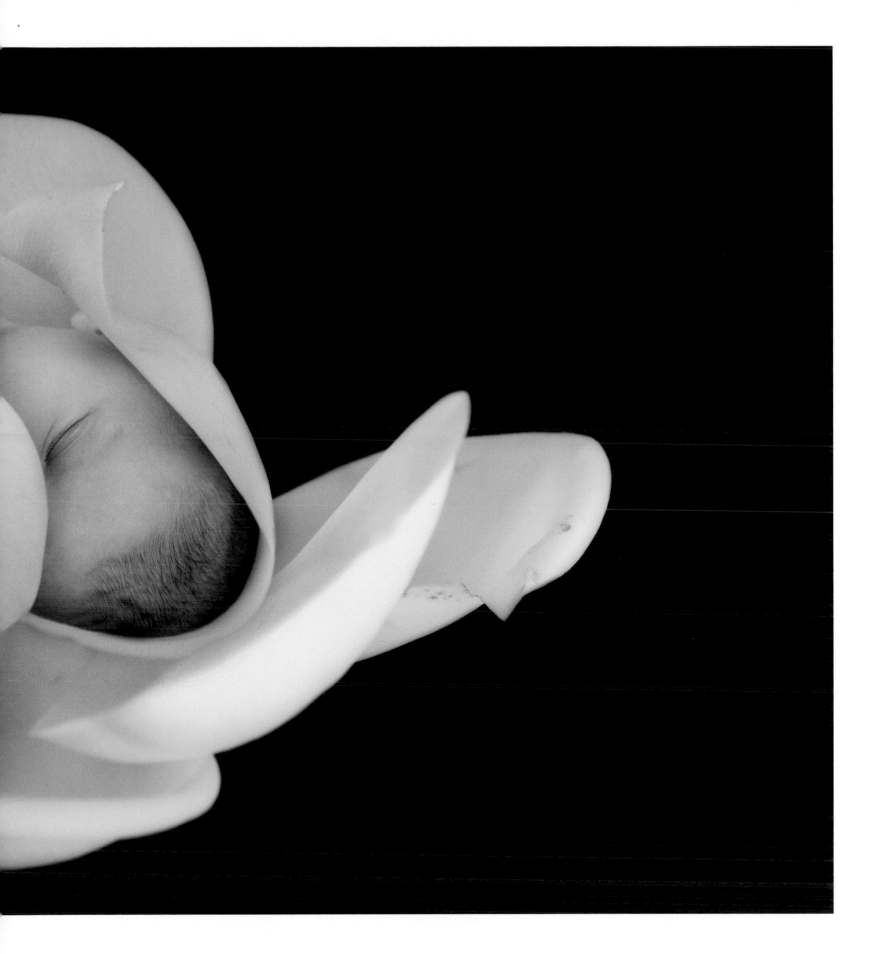

Children are the

living messages

we send to a time

we will not see.

John W. Whitehead (1946–)

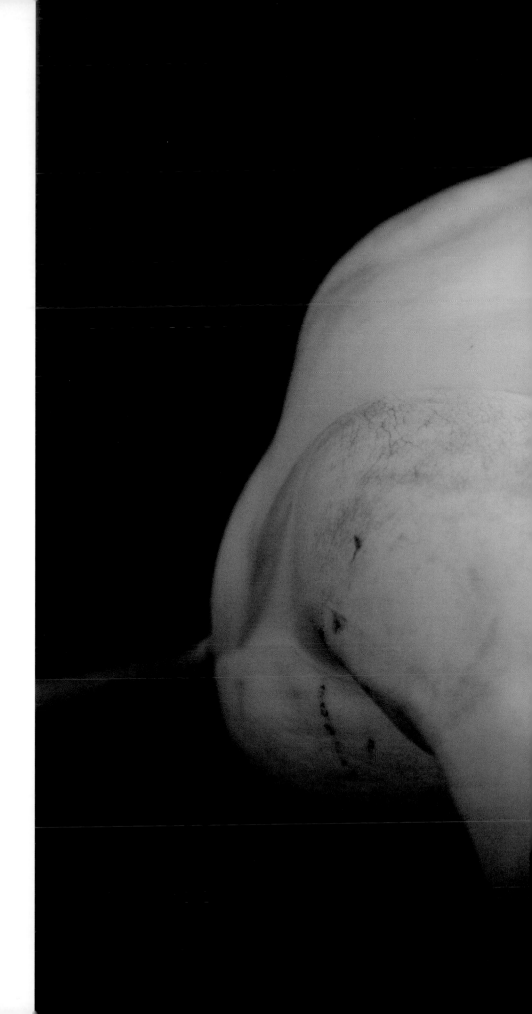

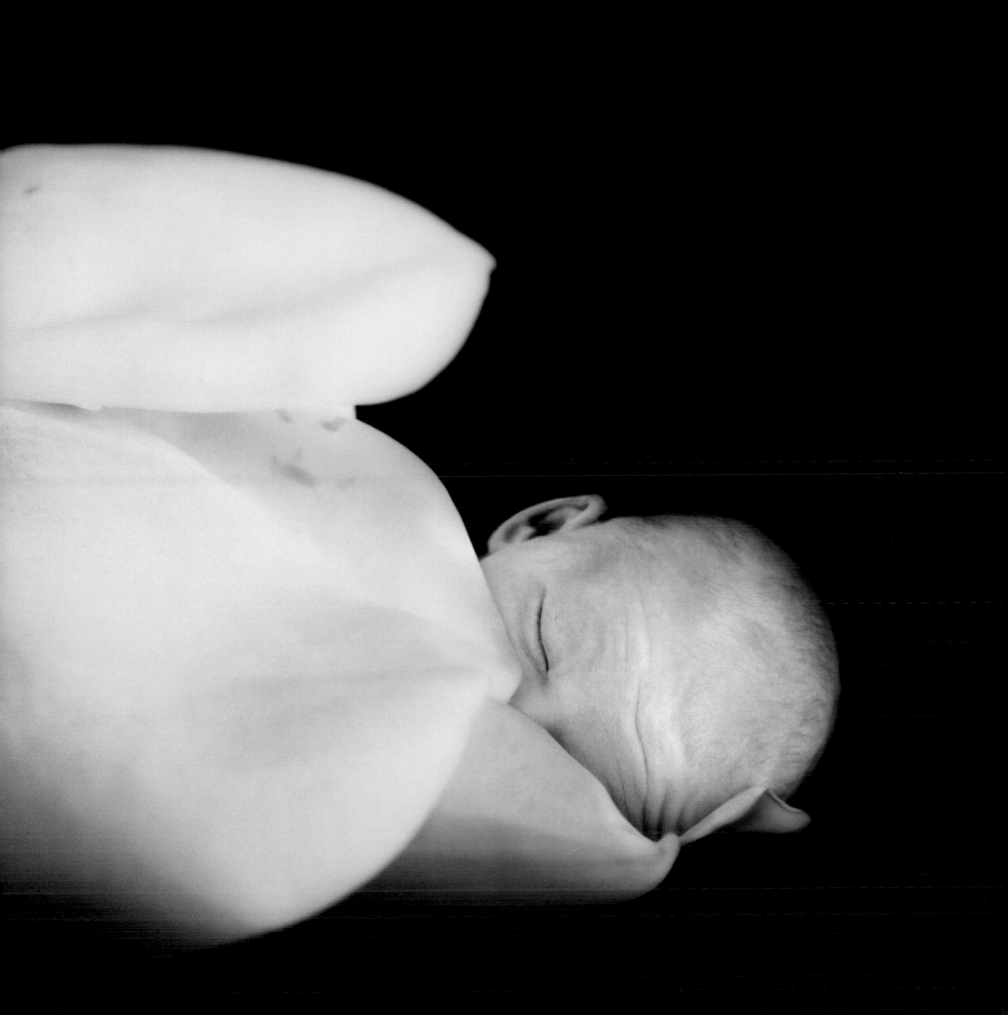

All that I *am*,

or hope to *be*,

I owe to my

angel mother.

Abraham Lincoln (1808–1865)

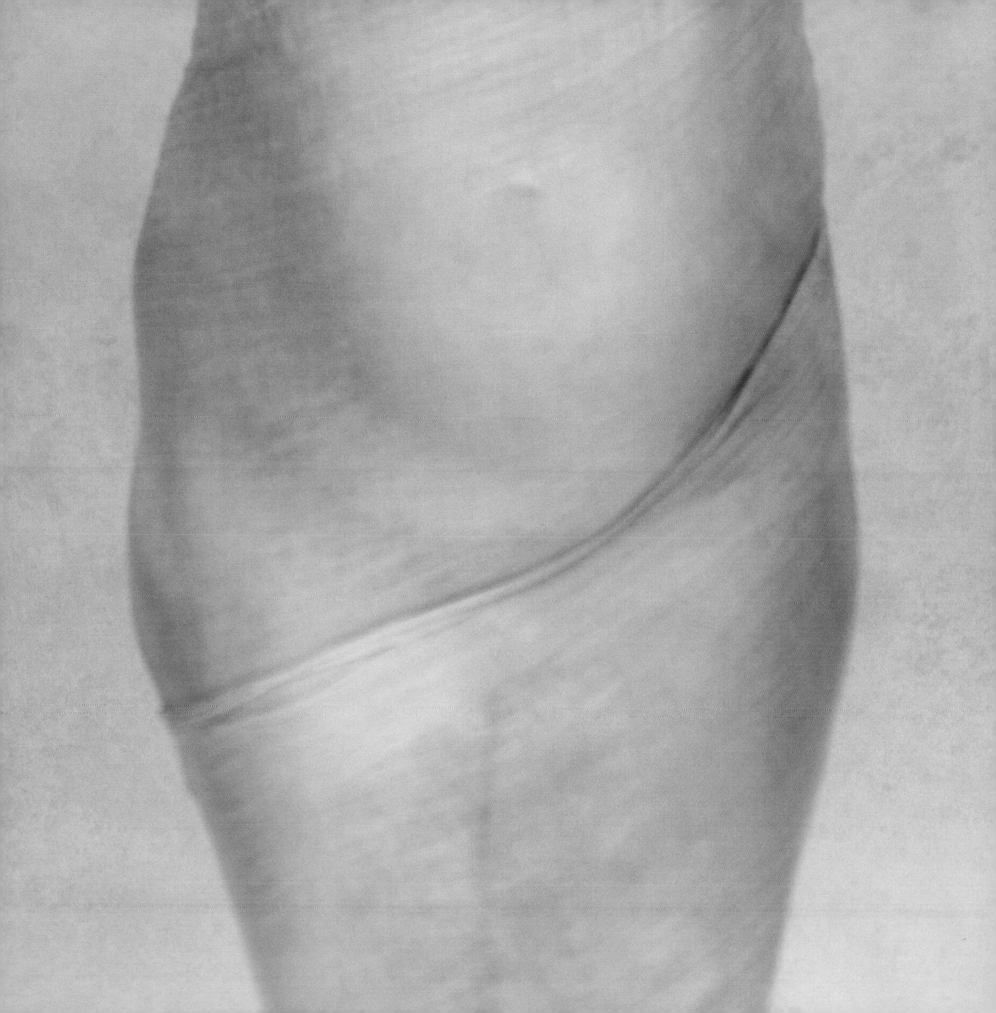

While we try to *teach* our children all about *life* . . .

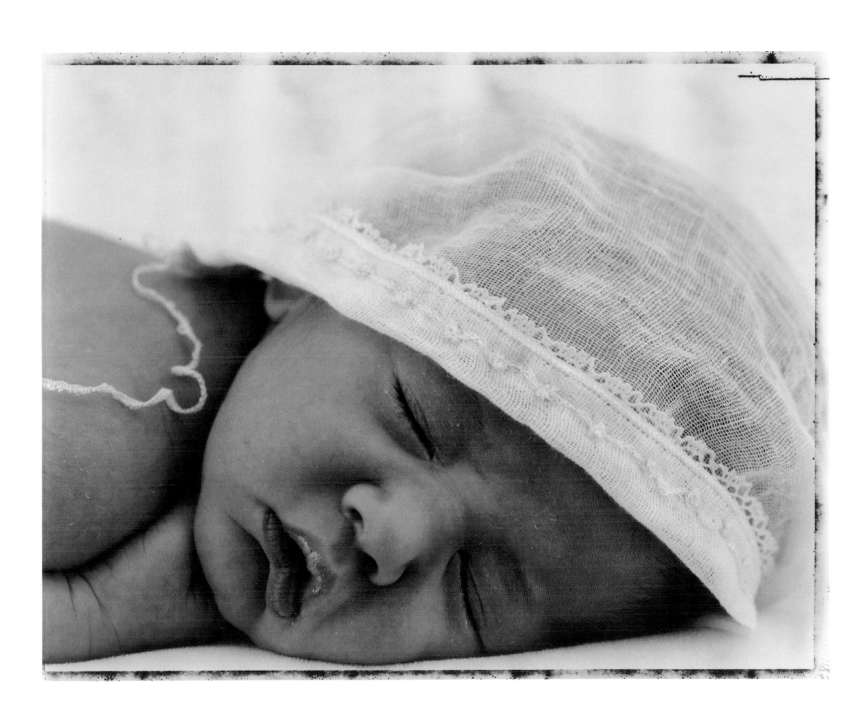

May the *wings* of the butterfly *kiss* the sun

And find your shoulder to light on

To bring you luck, happiness, and riches

Today, tomorrow, and *beyond*.

Irish blessing

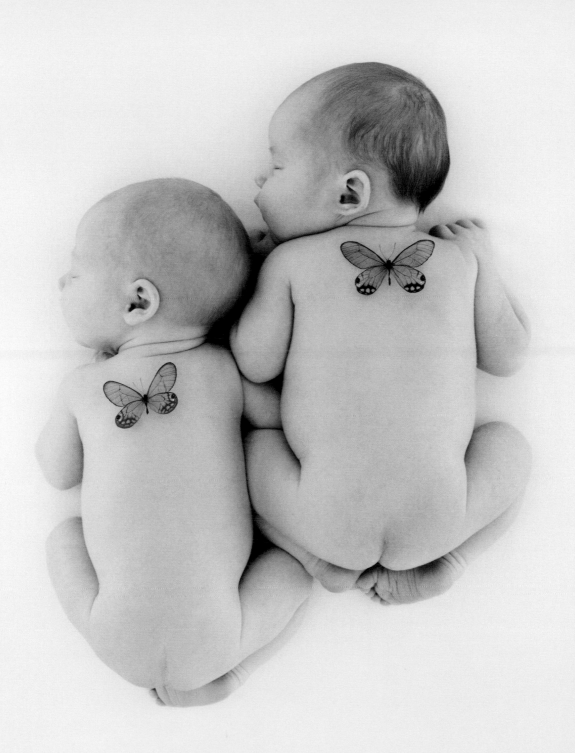

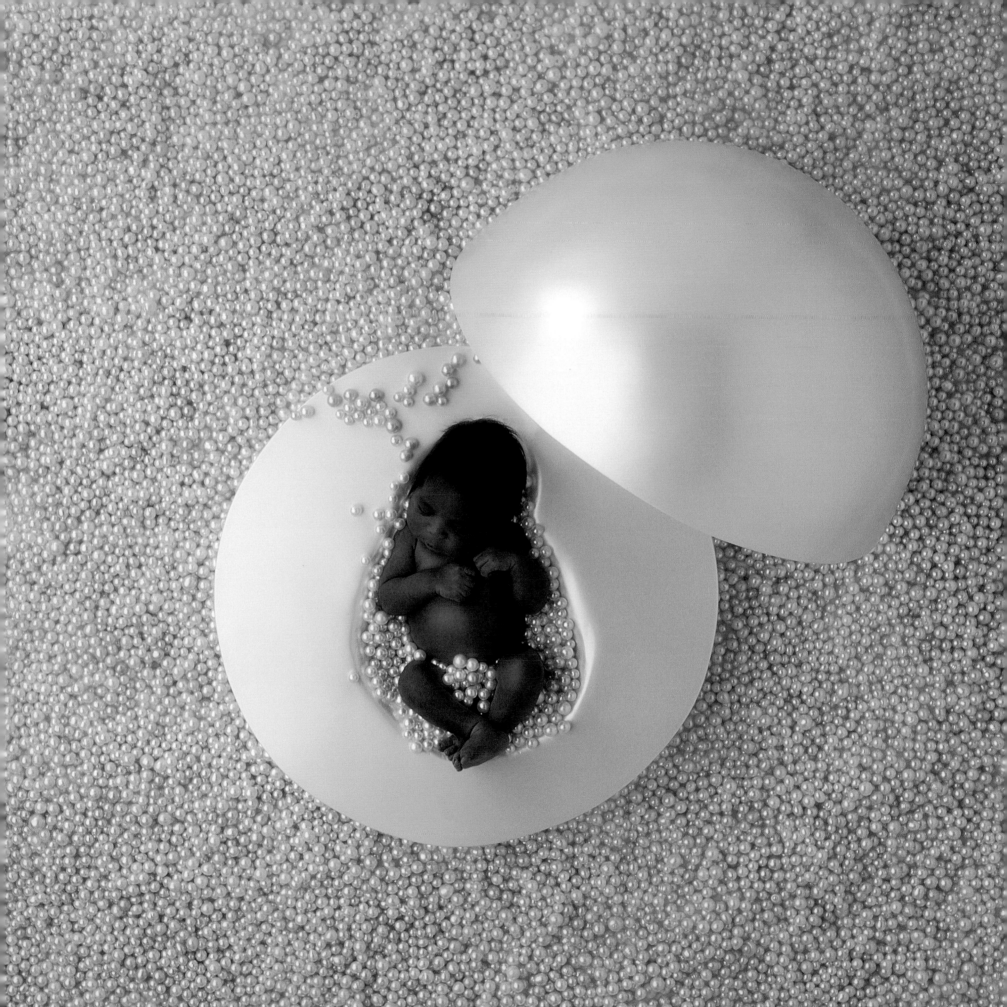

There is always one *moment*

in childhood when the door opens

and lets the *future* in.

Graham Greene (1904–1991)

There are two things in *life* for which

we are never *truly* prepared: *Twins*.

Josh Billings (1818–1885)

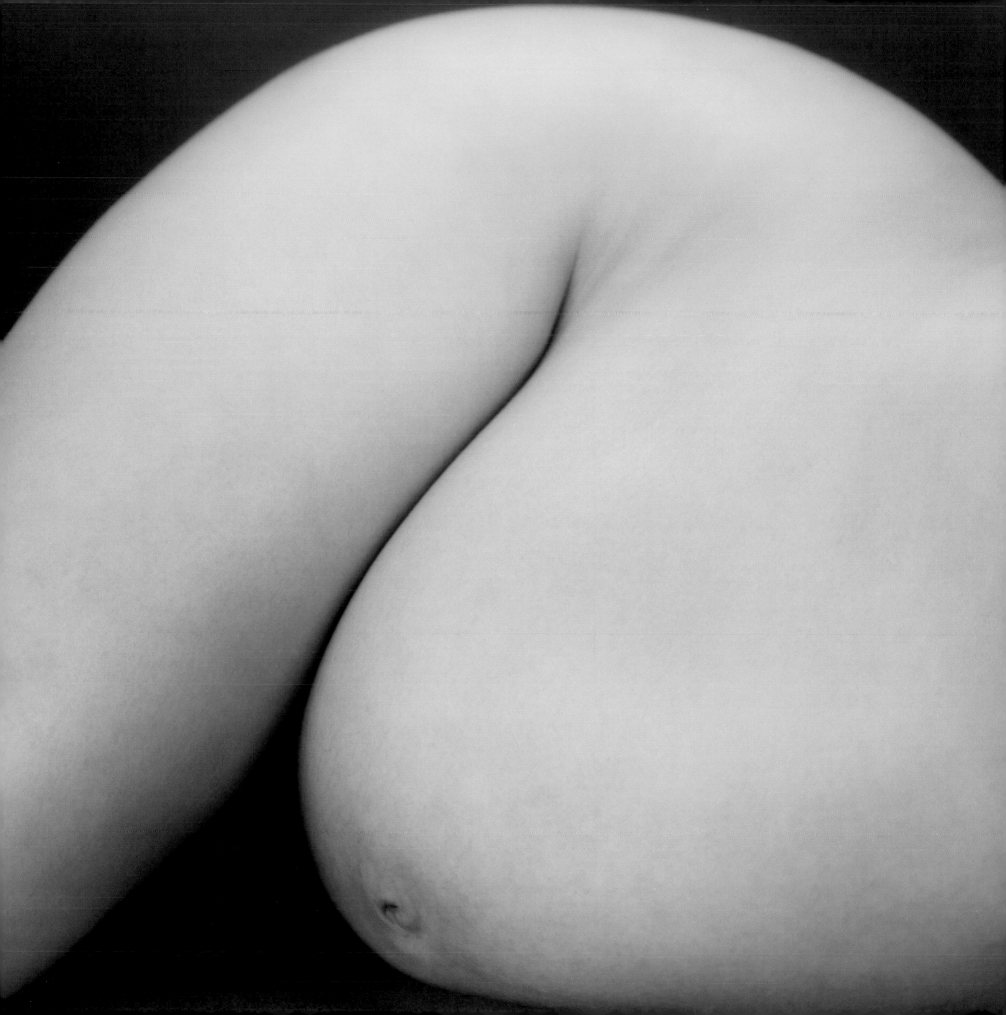

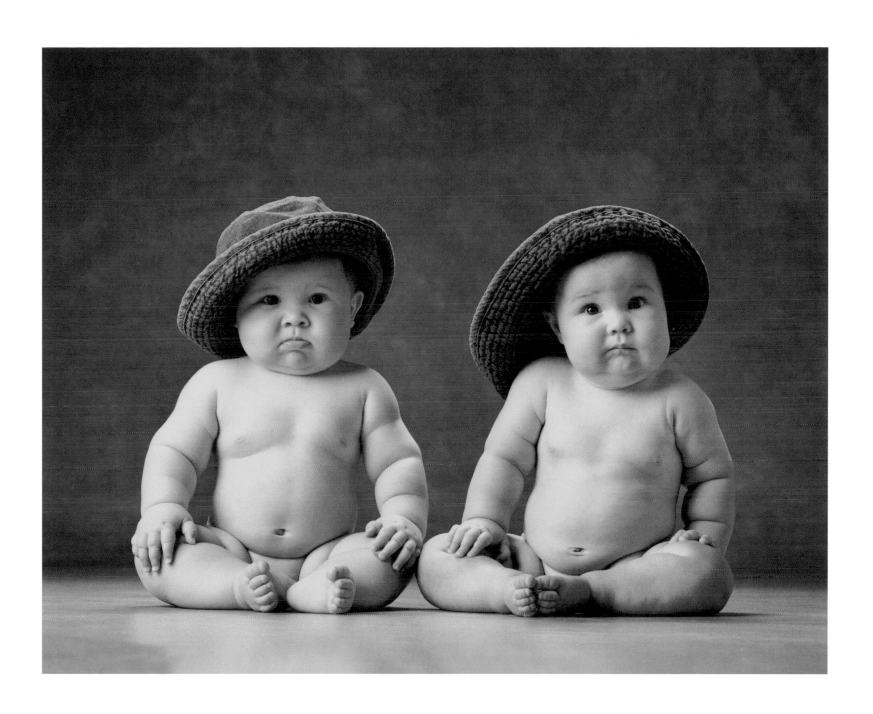

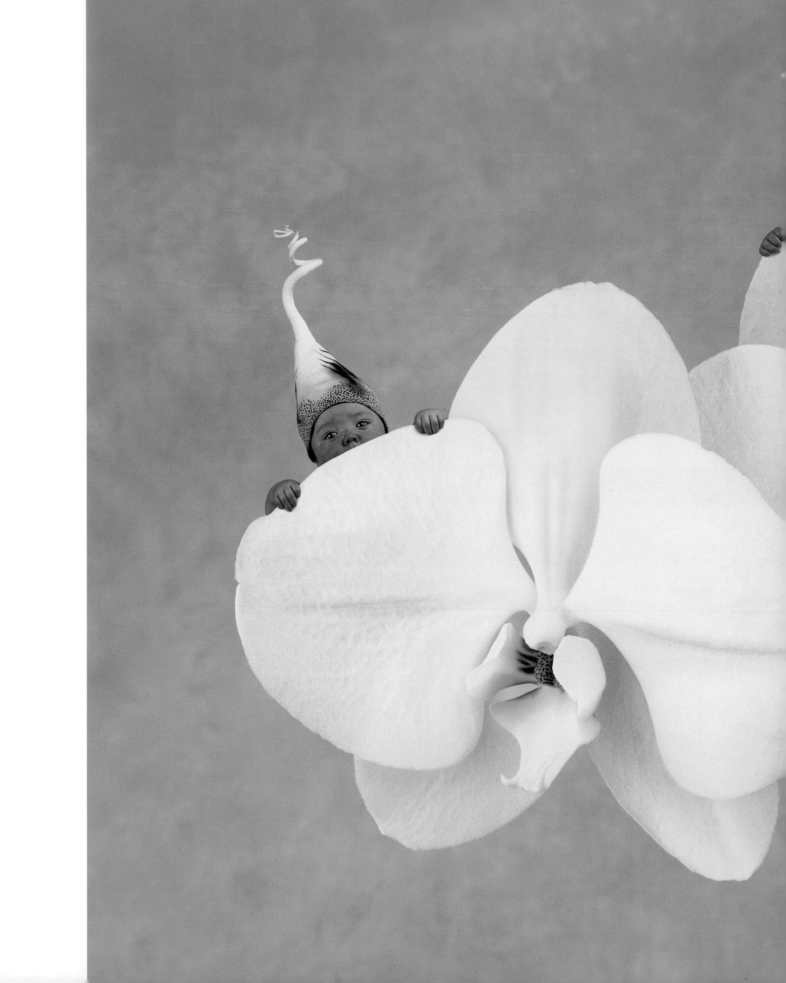

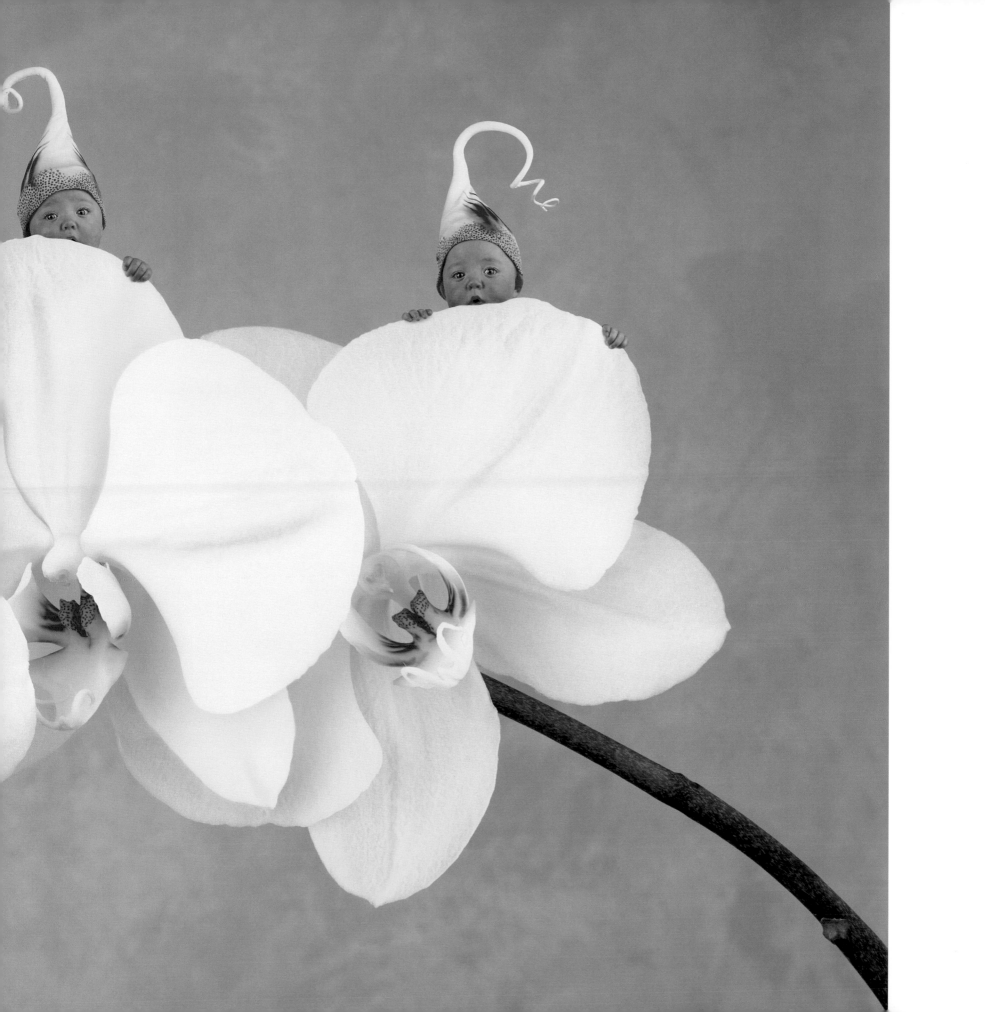

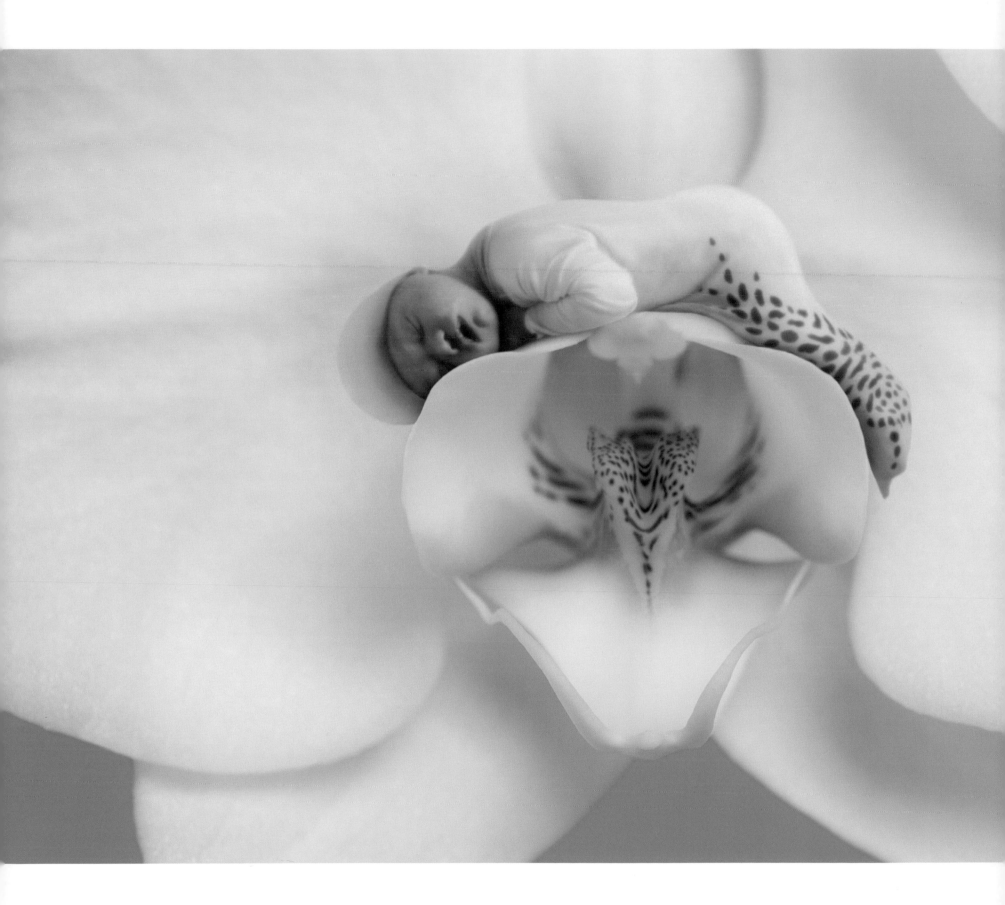

We worry about what a *child*
will become *tomorrow*, yet we
forget that he is someone *today*.

Stacia Tauscher

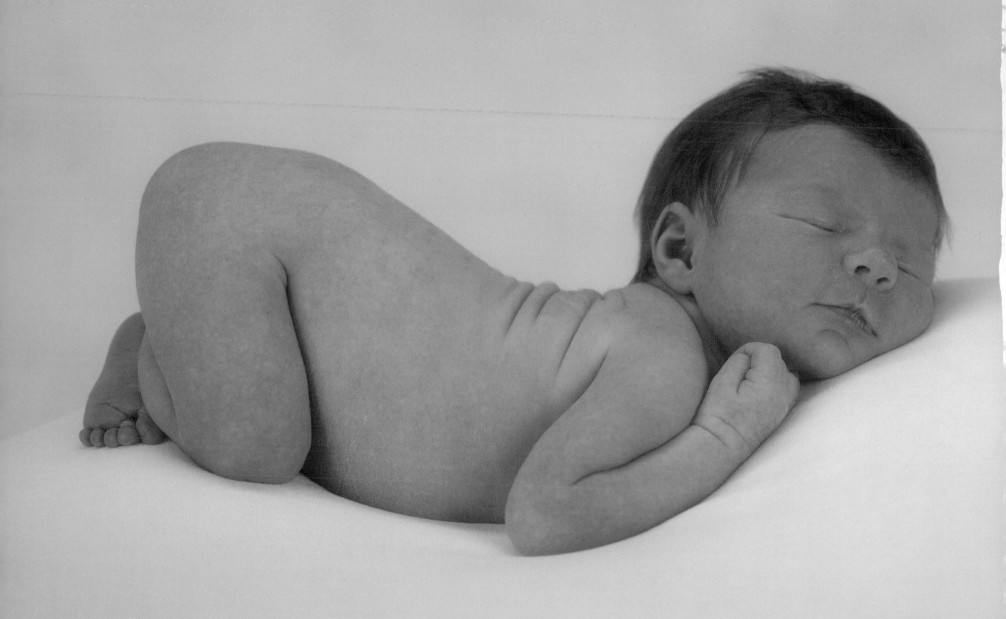

Babies

are always

more *trouble*

than you

thought—

and more

wonderful.

Charles Osgood (1933–)

The *family* is one of nature's *masterpieces.*

George Santayana (1863–1952)

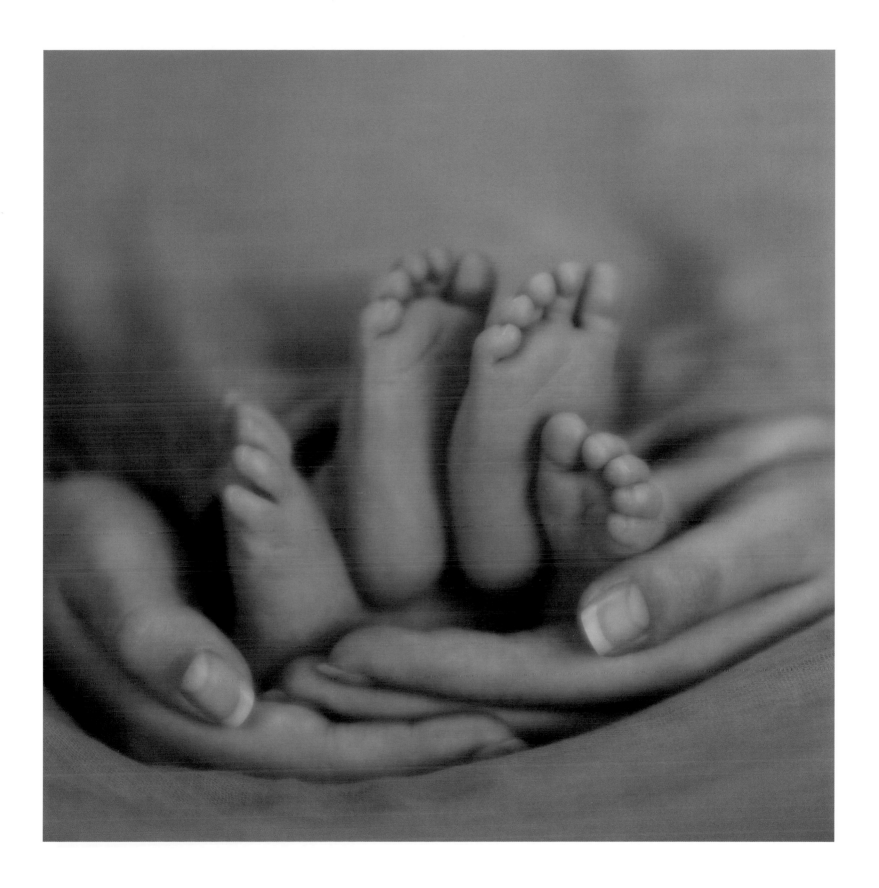

A mother's *arms*

are made of *tenderness*

and children sleep

soundly in them.

Victor Hugo (1802–1885)

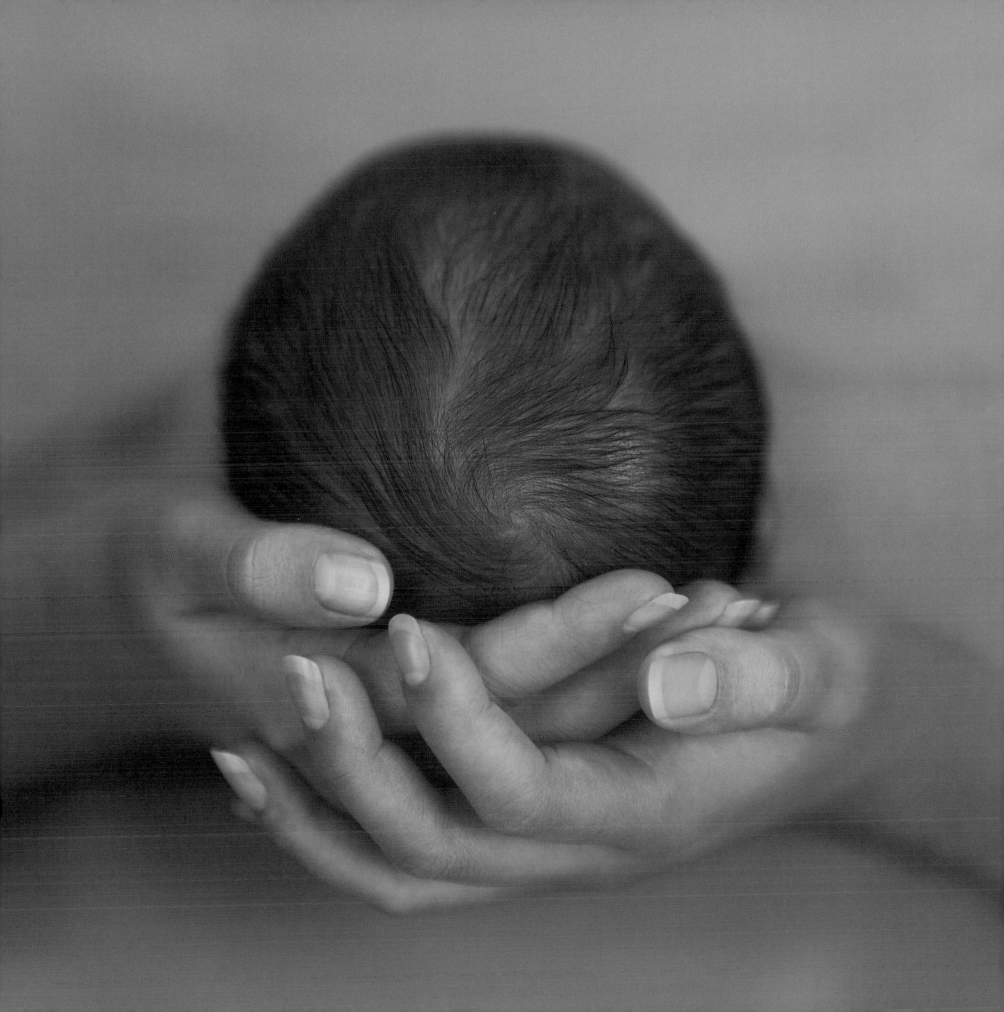

Love touched our very hearts

with tenderness anew,

the day we heard your little voice

and cast our eyes on you.

Author unknown

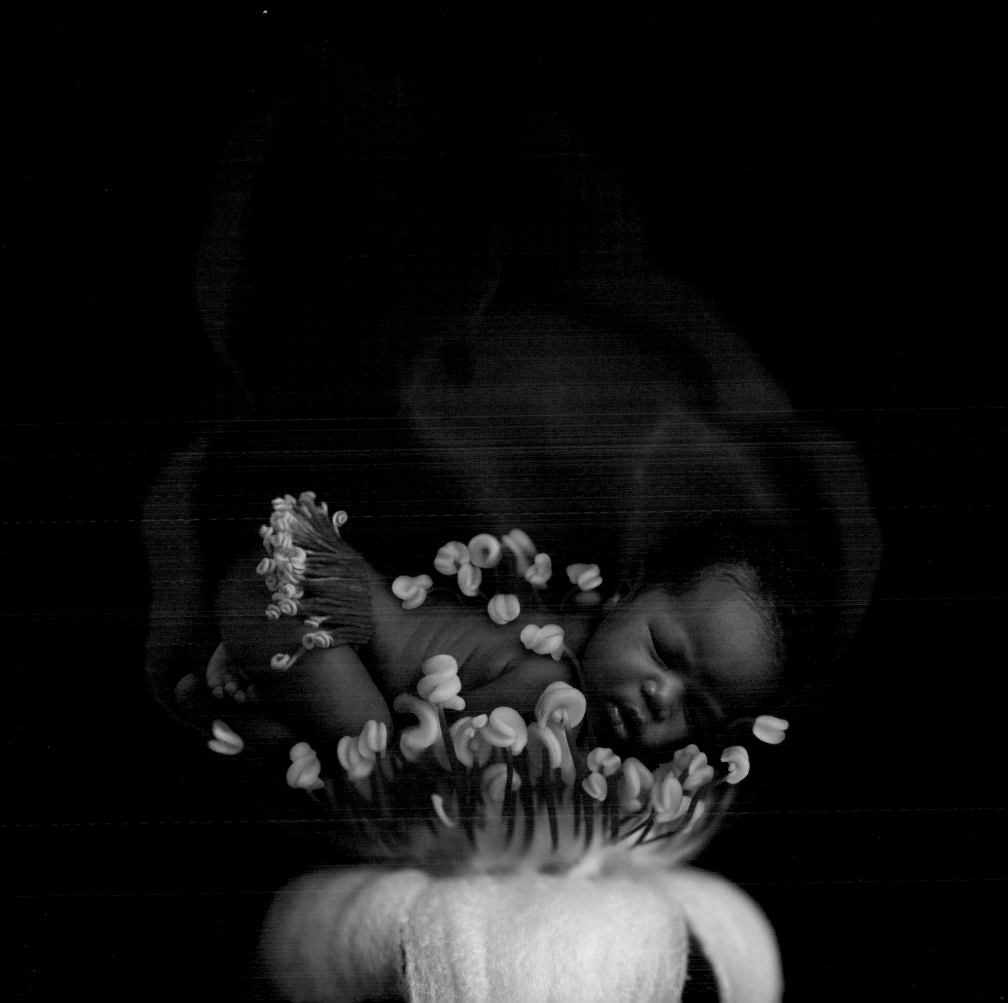